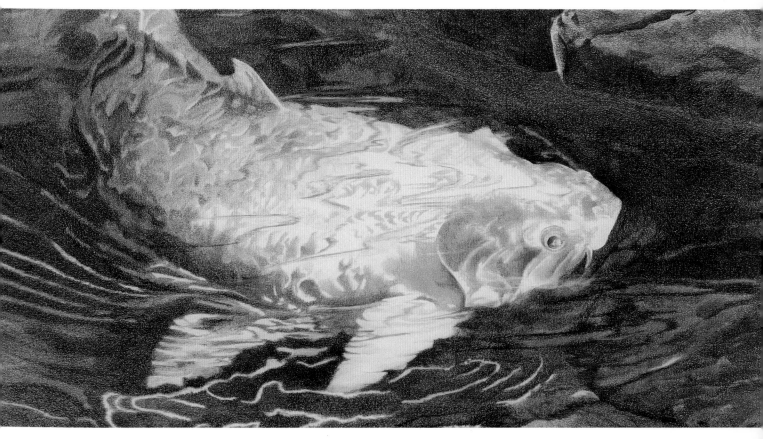

the
best
of
COLORED PENCIL 4

Copyright © 1997 by Rockport Publishers, Inc.

All rights reserved. No part of this book may be reproduced in any form without written permission of the copyright owners. All images in this book have been reproduced with the knowledge and prior consent of the artists concerned and no responsibility is accepted by producer, publisher, or printer for any infringement of copyright or otherwise, arising from the contents of this publication. Every effort has been made to ensure that credits accurately comply with information supplied.

First published in the United States of America by:
Quarry Books, an imprint of
Rockport Publishers, Inc.
33 Commercial Street
Gloucester, Massachusetts 01930-5089
Telephone: (508) 282-9590

Distributed to the book trade and art trade in the United States by:
North Light Books, an imprint of
F & W Publications
1507 Dana Avenue
Cincinnati, Ohio 45207
Telephone: (800) 289-0963

Other Distribution by:
Rockport Publishers, Inc.
Gloucester, Massachusetts 01930-5089

ISBN 1-56496-389-6

10 9 8 7 6 5 4 3 2 1

Designer: Beth Santos Design
Cover Image: Dyanne Locati p.140
Back cover images:
 (top) Rita Sue Powell p.139
 (middle) Richard Drayton p.92
 (bottom) Laura Westlake p.119

Manufactured in Hong Kong by Elegance Printing & Book Binding Co., Ltd.

Vera Curnow
Colored Pencil Society of America

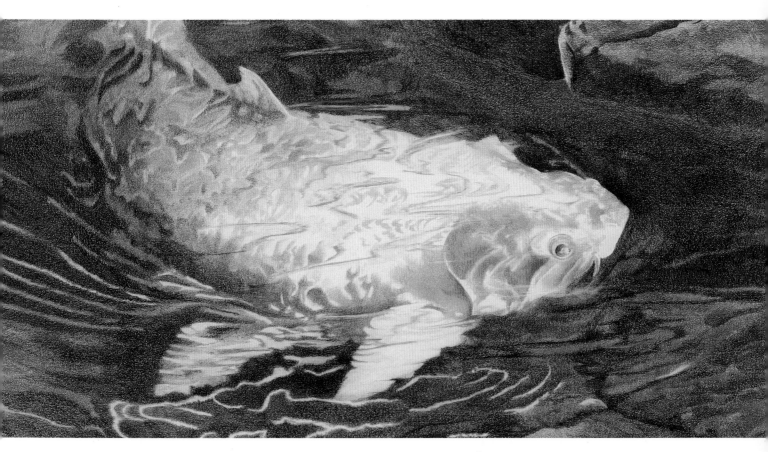

the best
of
COLORED PENCIL 4

Quarry Books
Gloucester, Massachusetts
Distributed by North Light Books, Cincinatti, Ohio

INTRODUCTION

It's over. The 4th Annual Colored Pencil Society of America (CPSA) International Exhibition held in San Diego, California, is now a memory. The colored pencil art no longer honors the walls of the Poway Center for the Performing Arts. The lights are off. The echo is gone. CPSA President, Rhonda Farfan; Exhibition Directors, Dyanne Locati and Bobbi Bradford; and the many sponsors, volunteers, and artists involved are actively focused on the needs of tomorrow's goals.

This book, however, while it completes the circle, is not about that which is ended. In fact, it takes us to the beginning—when all that existed was the artist, the muse, and that blank sheet of paper. The visual results shown here are truly a power pack of inspiration. But there is another dimension added that the judges could not consider and the Exhibition itself could not reveal: the motivations, revelations, and sometimes frustrations of the artist behind the work.

Included in these pages are the 145 art works selected from almost 1,000 entries by Exhibition Judges, Martin Petersen, Curator for the San Diego Museum of Art, and Linda Doll, Professional Juror, Instructor, and Painter. The works they selected represent a cross section of every style, technique, and subject in every field of visual-art expression—from graphic design to fine art. All the work is 100% colored pencil completed on a two-dimensional surface.

Just as this book will serve as a remembrance of one stop in the artists' journey, it will also address the motivation that drove them there. And it documents the incredible possibilities open to those who create with colored pencil. It's just the beginning.

Vera Curnow, Founder
Colored Pencil Society of America

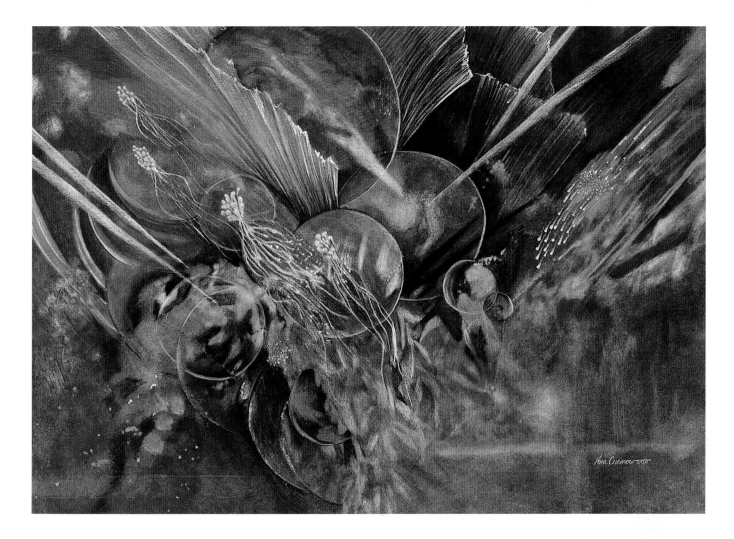

Performing an appendectomy, twirling a baton, driving a stick-shift automobile, juggling—these are manual skills that, with practice and repetition, can be learned. Just like drawing. Draftsmanship is merely a physical process: A.) being able to really *see*, B.) coordinating eye-hand movements, and C.) maneuvering small motor controls. Once these basic human functions are developed, we can draw. This act alone, however, does not make us artists—and the object that we accurately and literally record is not necessarily art. It is as different as copying down words or actually being a "writer." Beautifully lettering words others have written is not the same as composing a new combination of words that expresses a personal viewpoint.

VERA CURNOW, CPSA
Spawn Shop
30 x 40 in. (76x102)
Surface Used: Crescent 100 Cold Press
 Illustration Board, White

"Spawn Shop" is a visual interpretation of movement and energy. Working on stark white board, dry pigments were mixed with mineral spirits to create dense color saturation. The composition and content were spontaneous and evolved as the work progressed.

VICENTE EDGARDO
High Emotions
29 x 35 in. (74x89 cm)
Surface Used: Strathmore 500 Bristol, White

This large scale drawing is done with water-soluble pencils in both wet and dry form. Edgardo begins with thin layers of light colors and builds to the darkest shades until every shape is heavily saturated. He applies pigment with either a N°.3 sable brush or a wet pencil point.

I am strongly influenced by my culture and want to capture the rich colors that affect every aspect of that life. In *High Emotions,* the seemingly random patterns and rich, vivid colors capture the crowds of people and the landscape of my country, El Salvador. The first impact conveys a sense of chaos. As the viewer becomes more involved, however, the large palette of explosive hues and the interactive forms reveal the energy and beauty of the Spanish culture. I express abstraction with a presentation of color and reality through the use of shape.

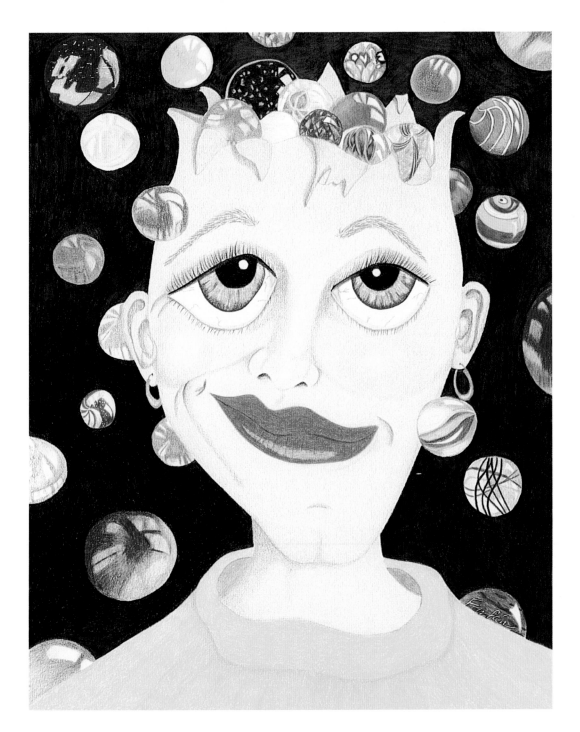

Working from photographs is too confining for me. The notion of making a picture that looks like something, someone, or some place in particular usually doesn't interest me. Imagination, exaggeration, and oddity appeal to me. *Awaiting Notification* is one painting in a series. Although the women's faces differ in the series, they are self-portraits in that I am the reference material for the emotions they convey. This painting is a humorous look at how I feel after entering a show and waiting to be accepted or rejected. It reminds me that my motivation for art lies in the love of its process.

RHONDA FARFAN
Awaiting Notification
20 x 16 in. (51x41 cm)
Surface Used: Rising 2-Ply Museum Board,
 White

To darken the background, Farfan uses water soluble graphite under black, indigo blue, and dark green. She begins skin tones with layers of green and yellow, allowing them to show through the more traditional flesh colors added over them.

CHRIS FRIESEN
Raspberries
17 x 17 in. (42x42 cm)
Surface Used: Strathmore 80 lb. Watercolor
Paper, White

Friesen uses various light, medium, and dark
values in red, orange, yellow, blue, and purple
for this drawing. She leaves the background
white to add to the brightness.

I love red. But mainly, I just wanted to do
an illustration that was cheerful and
bright.

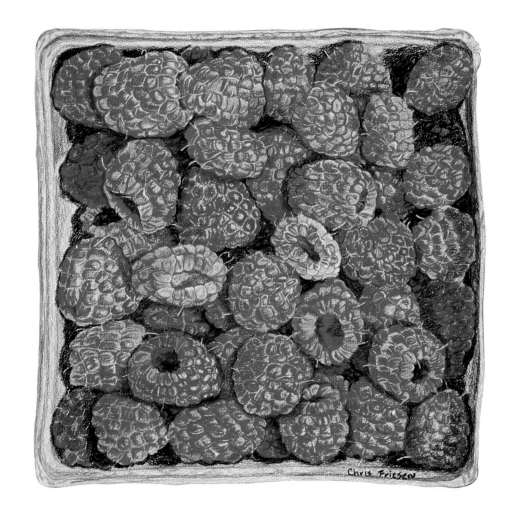

SHANNON CUTRI
Gumballs
9 x 12 in. (23x30 cm)
Surface Used: Arches 140 lb. Hot Press
Watercolor Paper, White

The bright colors in this painting are applied
with heavy pressure to obliterate the white of
the paper surface. Cutri then defines the shad-
ows and details. She uses an X-Acto knife to
scrape color and then reapply lighter hues in the
highlight areas.

The advertisements in this piece, along
with the repetitive shapes, symmetry, and
bright colors, attracted me to the subject.
At first glance, the machines and their
contents looked complex, but closer
observation showed they were just a com-
bination of circles and rectangles. I origi-
nally attempted to paint *Gumballs* with
watercolors, but found I couldn't capture
the bright, opaque colors or get the details
that colored pencils would provide.

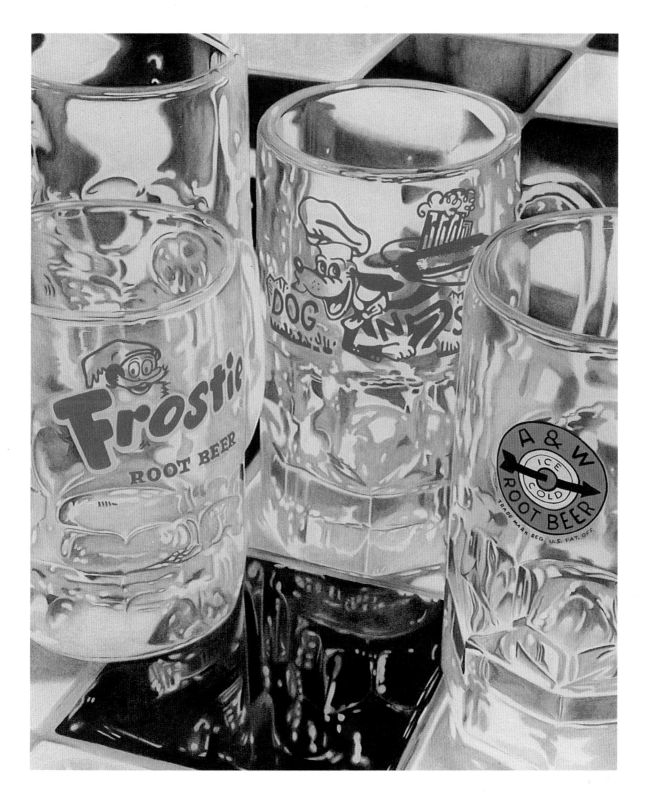

Much of my subject matter comes from the 1940s and '50s—some are vague memories, others are so common we forget to look at them. Using elements that may or may not have a direct relationship, I arrange a still life with differing light angles of various intensities. When the light and shadow "feel right," I finish composing the scene—cropping and creating perspective—through the lens of my 35mm camera. All this results in a painting that evokes a sense of surrealism to an often overlooked subject.

RICHARD TOOLEY
Trophies
22 x 18 in. (56x45 cm)
Surface Used: Crescent 201 Hot Press
 Illustration Board, White

Tooley chooses the mugs because of their faceted glass and colorful logos. He burnishes his limited palette of nine colors to a smooth finish using a selection of paper stumps and paper toweling. He sprays the completed piece with a workable fixative.

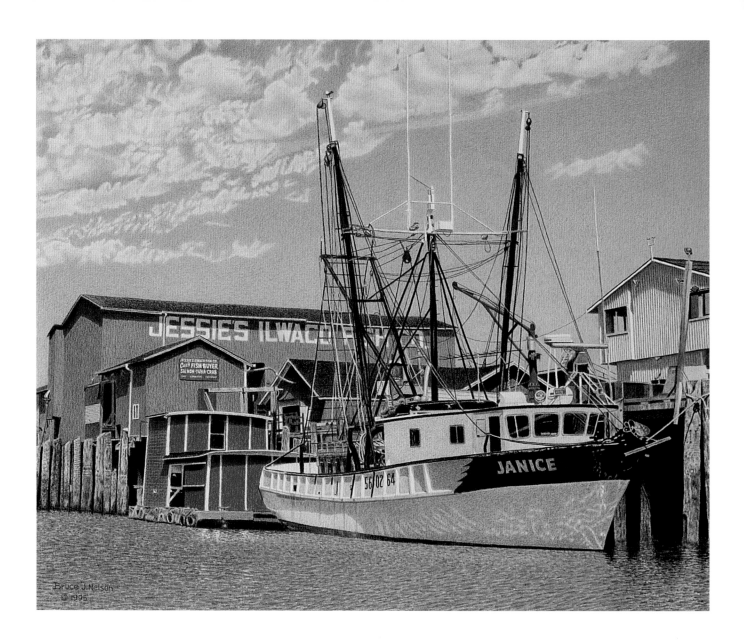

BRUCE J. NELSON, CPSA
End of an Era?
19 x 23 in. (48x58 cm)
Surface Used: 2-Ply 100% Rag
 Museum Board, White

Working from light to dark colors, Nelson uses the layering method in most of the painting. In the dock supports and water, however, he optically mixes colors by using a pointillism technique of tapping pencils on the surface to create dots.

For years I drew in monotone. I tried working with color in the early '50s but was less than successful. I just kept at it over the years until I finally got it together. This reference photograph was taken ten years ago. If I had done the painting at that time, I wouldn't have titled it as I did—the fishing industry has declined greatly in the last ten years. I hope the viewer finds the beauty of this scene and takes a few minutes to enjoy my rendition of it.

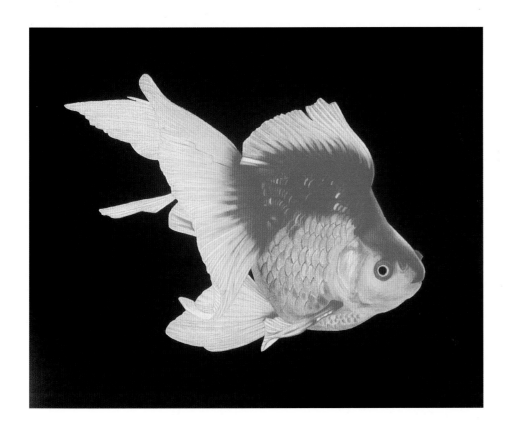

GREGORY S. PILCHER
Angelfish
11 x 14 in. (28x36 cm)
Surface Used: Strathmore Drawing Paper, White

After completing the subject, Pilcher uses black colored pencil to completely obliterate the white surface around it. He makes a tortillon from a folded matchbook cover to blend and burnish the layers of color.

I chose the goldfish because it portrays the profound beauty that God created it with, which is the motivating force behind all of my work. Being an artist gives me the opportunity to share with others the joy of what I see in life.

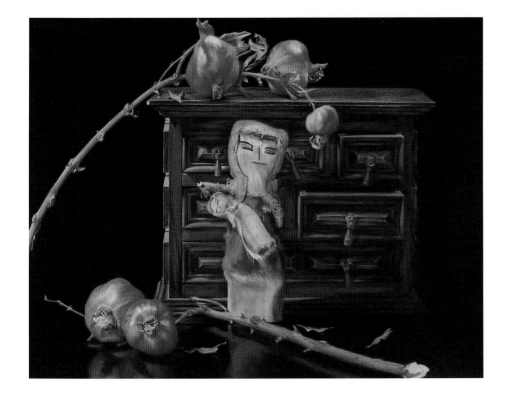

NANCY BLANCHARD
Mythology I
32 x 40 in. (81x102 cm)
Surface Used: Rising 4-Ply Museum Board, White

Blanchard painted "Mythology I" on a white surface, choosing to create the dark background with warm and cool colors. She never uses black. There is no erasing—any mistakes are simply made part of the work. She uses several hundred pencils of various brands on this size work.

After researching their meaning in mythology and lore, I decided to create a colored pencil painting around pomegranates. I worked directly from the still life I arranged and began with the local color of whatever area I worked on. I continued to layer colors until I had what I saw before me and wanted to show. My intent was to simply interest the viewer in a story I had created. Since I am the author, I tell it differently from any other person.

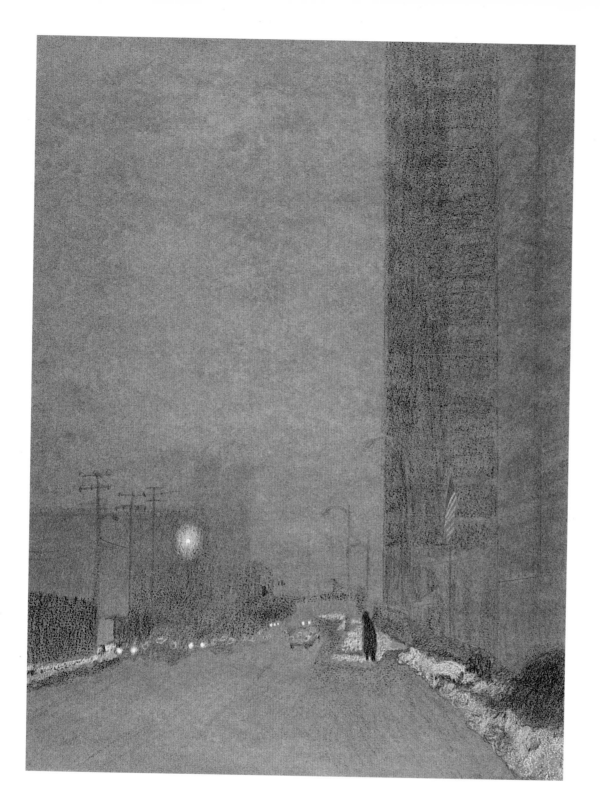

ARLENE WEINSTOCK
February
24 x 17 in. (60x43 cm)
Surface Used: Ingres Paper, Dark Blue

Weinstock places textured boards under a thin, strong paper and rubs art sticks and colored pencils over the paper surface. By moving the paper or changing the boards beneath it, she is able to create and combine various textures. This "frottage" technique allows the color of the paper to show through the pigment.

Being interested in how mist, pollution, or fog affect what can be seen, I decided to take pictures on a very foggy February morning. I was taken by the solidity of the mist and how it seemed to eat the light. The major difference between the photographs I took and the painting is the vertical composition. By changing the format, I was able to enhance the sense of weight I felt from the thick air and to visually share the cold dampness. For me, the subject of this piece is not the details of this street, it is the crisp quiet of a winter's morning.

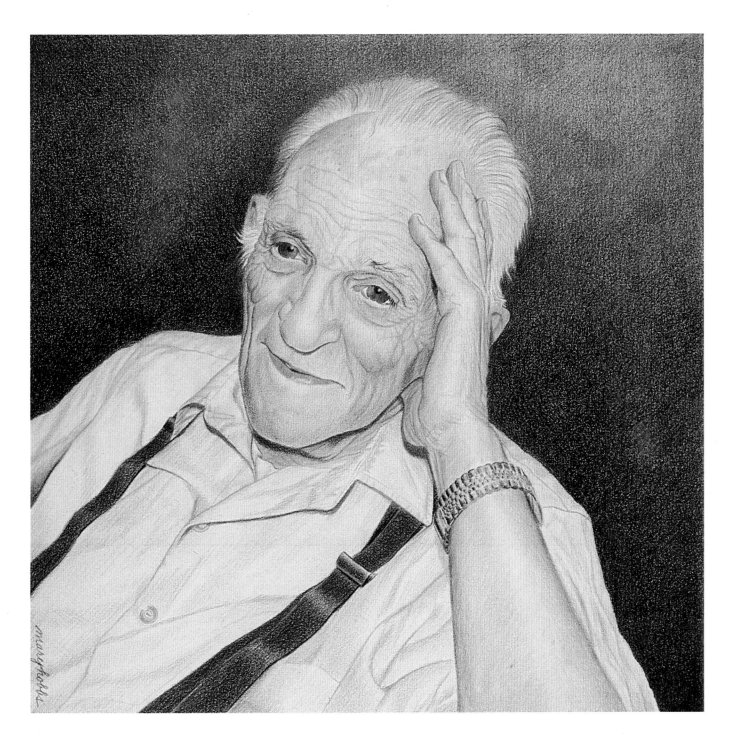

Dad at 95.... Every Friday afternoon I visit him. But who I am and where he is are now just fleeting reality. The challenge in portraying Dad, since he always wears white and is so fair, was to get enough contrast into the painting without overpowering him. My Dad is very dear to me. At the age of 93, he was still bowling three times a week; to now witness his despair, his lust for life gone, makes me sad. This painting is in tribute to him.

MARY G. HOBBS
Dad at 95
18 x 18 in. (48x48 cm)
Surface Used: Crescent 2-Ply Mat Board #1607

The background and suspenders are soft and do not detract from the face. Hobbs uses sharp pencils to crosshatch strokes in various directions, lifting and reapplying color to maintain the balance.

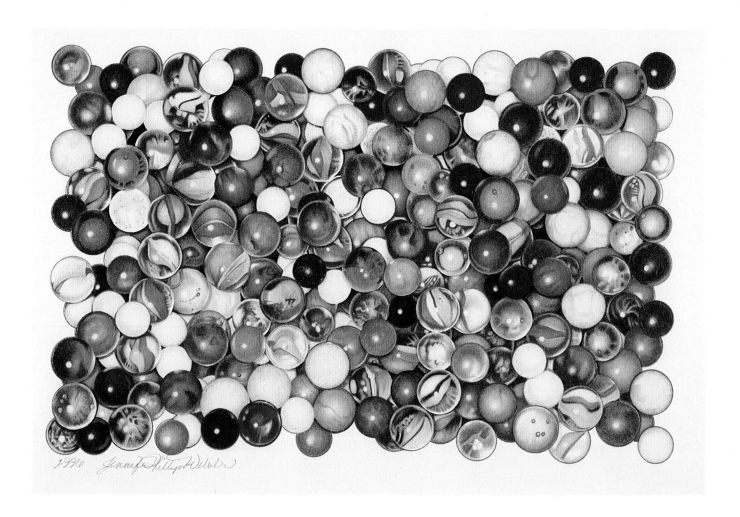

JENNIFER PHILLIPS WEBSTER
I've Lost a Few Myself
6 x 9 in. (15x23 cm)
Surface Used: Canson 2-Ply Bristol, White

To capture the uniformity of the man-made shapes, Webster uses a circle template. She draws only a portion of the objects at a time and completes that section before expanding the composition. She applies graphite over the colors to blend and deepen darker values.

Many people, places, and things have become my subject, but I get the most satisfaction with a work full of detail or a story to tell. It was during a blizzard that I faced the challenge of this painting—housebound for the better part of five days with my husband, mother-in-law, 2-year-old toddler, a cat, and no bread. Six marbles into the drawing, I was hooked—by the end of the second week, I was ready to call it quits. When appropriate, I prefer playful titles; however, I take my work seriously and render each piece with acute sensitivity. I have never let a painting go untitled.

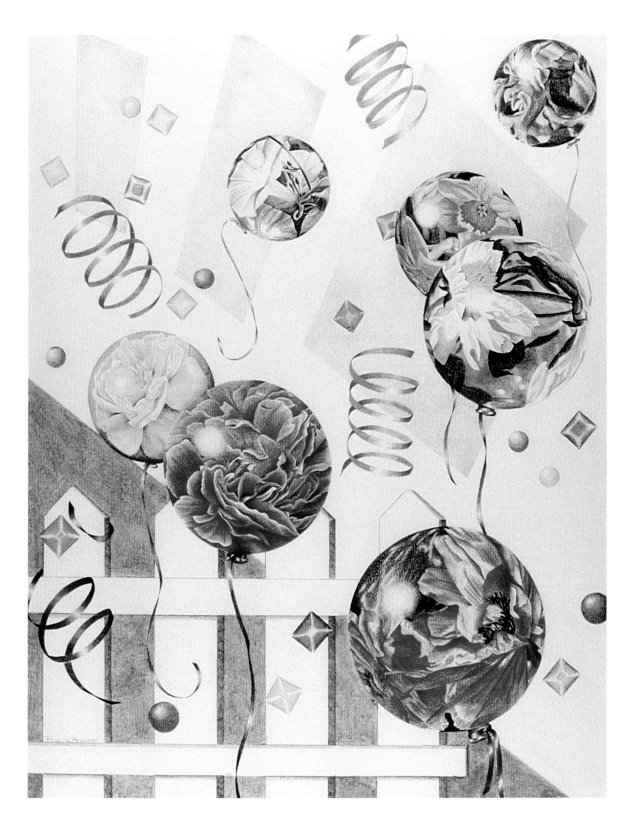

When I create a painting such as *Garden Party II*, it usually begins with one idea and tends to develop as the work progresses. I wanted to convey a happy party feeling while retaining an atmosphere of fantasy. The confetti-type objects and curled ribbons add to the party mood while the picket fence keeps the event down-to-earth. Rather than draw a backyard, I indicate the ground with a diagonal division of space; the sky is implied with irregular shapes of blue. The unique placement of flowers in floating balloons encourages viewers to look at a common subject in a new and different way.

PRISCILLA HEUSSNER, CPSA
Garden Party II
28 x 22 in. (71x56 cm)
Surface Used: Rising Stonehenge, White

Heussner manipulated the flower photographs into circular shapes with a computer before transferring them onto the drawing surface with an opaque projector.

SUSAN Y. WEST
Sundancers II
14 x 17 in. (36x43 cm)
Surface Used: Rives BFK Paper, White

By varying the degrees of pressure, West creates a contrast of low vs. high color saturation. She never uses a white pencil and rarely uses black. The work was done in blues and French grays accented by the warm tones of the feet, hair, and cat's eyes.

My husband Robert saw one of our cats warming herself in the sun streaming through the front window and lay down to pet her. The morning light against the forms in *Sundancers II* created an interesting, yet simple composition. The body of the figure posed no particular problems to render. The floor, however, was the open-ended question. The challenge was to keep this background sublimated yet interesting enough to add to the overall effect. What colors were needed? How dark did it need to be? I chose an almost monochromatic color scheme and mapped out only the sunbeams that were essential.

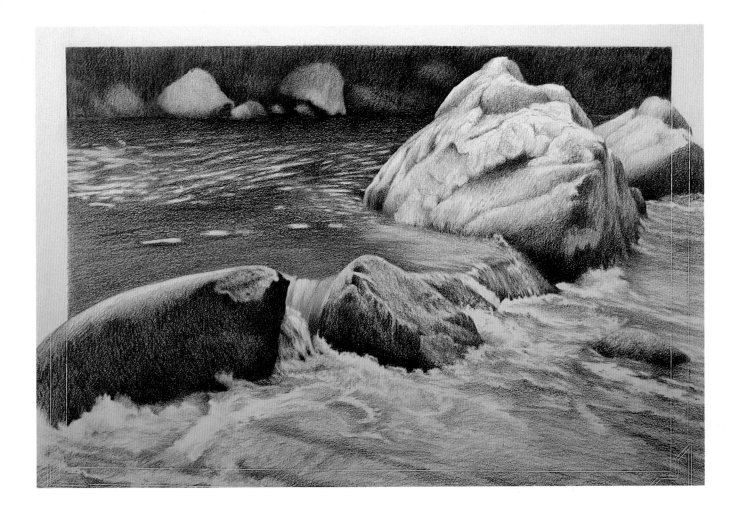

My camera has replaced the need for hours of sketching. I take photographs from speeding vans, bumpy boats, and swaying ski lift chairs. I do not care if part of the image is blurred. All I need is a fleeting impression of the landscape. While I normally compose static compositions with calm lakes and placid rivers, I was intrigued by the way the huge boulders diverted the force of the water. The shore serves as a backdrop to emphasize the surging water and diagonal line of the boulders. This scene expresses my fear and awe of the river's power.

LINDA WESNER, CPSA
Memory Etch I
13 x 20 in. (33x51 cm)
Surface Used: Strathmore 4-Ply Acid-Free
 Illustration Board, White

To create the dark background, Wesner alternates cool and warm colors with a tonal application. She uses linear strokes over this to imply foliage. The strokes in the water current follow the direction of its flow. The artist spot burnishes only to emphasize highlight areas.

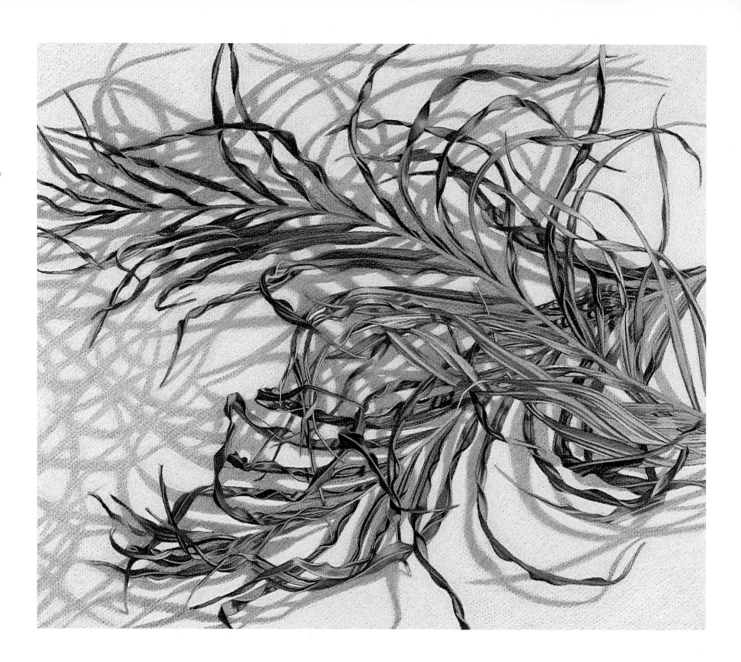

DENA V. WHITENER, CPSA
Afterlife Study #3
14 x 17 in. (36x42 cm)
Surface Used: Canson Mi-Teintes

Whitener begins by laying dark colors first. She
completes an underpainting using 90% and 70%
warm grays and then white. She applies color to
this grisaille with short hatched strokes until the
subjects become defined, and then finishes the
layers by following the contour of the object.

After my botanical ineptness had caused its demise, the palm plant had turned into lovely muted
oranges, reds, and greens. I was attracted by the curving lines and fluidity of the fronds. And when I
placed them on a piece of white board, the shadows created echoing patterns. This interplay of shadow
and form always appeals to me.

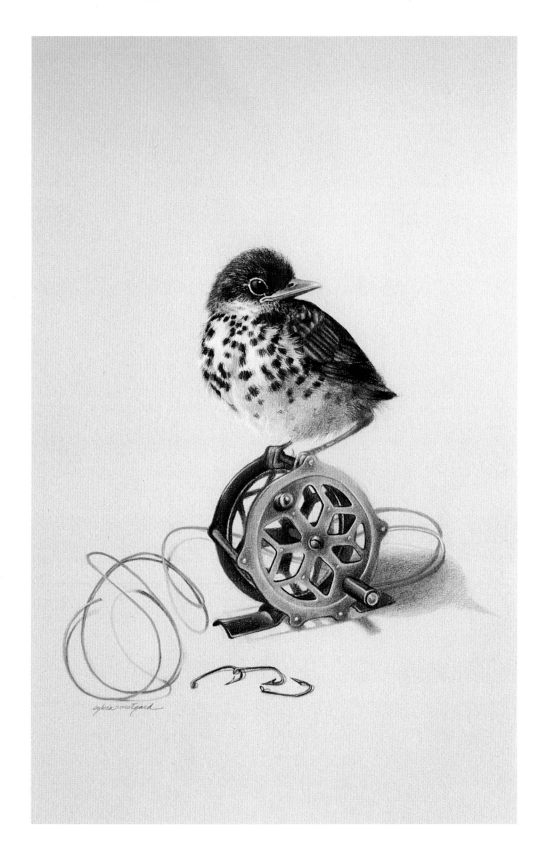

As a wildlife artist, I find the greatest satisfaction and energy in my work when I can add an animal or bird to the image. As a purist, I choose not to put a background behind the image. I feel that this subject doesn't need to be explained any further by adding context. The title says it all. With the loss of habitat, perhaps the only pictures of some animals in the twenty-first century will be on an artist's canvas, and life as a wildlife artist will have a new meaning and commitment.

SYLVIA WESTGARD
You Use the Worms for What!?
11 x 12 in. (28x30 cm)
Surface Used: Acid-Free Museum Board, Ivory

To get dense blacks, Westgard blends a heavy application of ivory black with a clear colorless marker, and then applies chocolate brown and more ivory black layers.

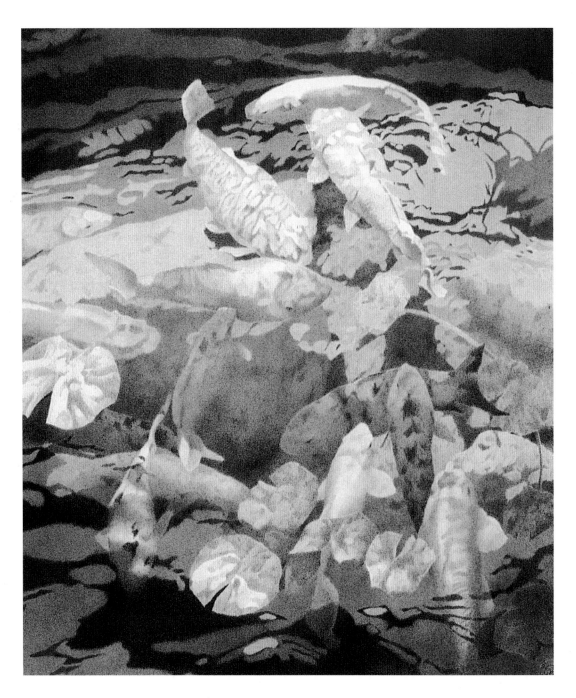

JANE WIKSTRAND
Koi
31 x 28 in. (79x70 cm)
Surface Used: Strathmore 500 4-Ply Bristol
 Vellum, White

The artist uses the transparent and opaque
reflections of the water as part of the design
element. A combination of warm and cool col-
ors applied with dark and light values keeps
Wikstrand's fluid subject from looking static.

I came upon this pond in an outdoor courtyard while shopping in Arizona. It struck me as incongruous to find this scene in such arid surroundings. Water has always been one of my favorite subjects because of its transparency and how it reflects and diffuses light. There is interest above the water surface (water lilies, cattails, etc.) and below it (fish, seaweed, etc.). This creates a multifaceted visual experience and design which I love interpreting in colored pencil.

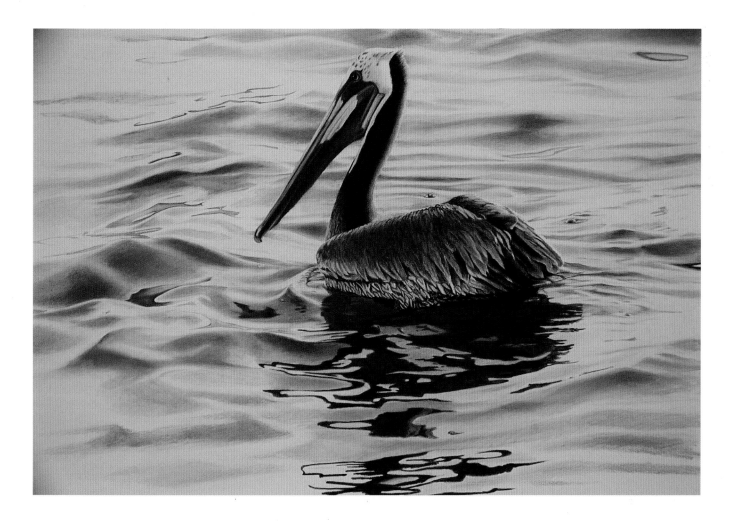

I began working with colored pencil in 1956 and have been teaching this medium for the past twenty-four years. I will use any brand that can supply a color I do not have—I have had every colored pencil made and am still looking for colors. This medium is ideal for realistic rendering. In *Channel Islands Regular*, I found the smooth texture of the water, contrasted with the coarseness of the pelican's feathers, very appealing. My focus was on the reflections of the rolling water; and so, for me, this is the real subject matter of the painting rather than the bird.

LARRY D. WOLLAM
Channel Islands Regular
17 x 22 in. (43x56 cm)
Surface Used: Aquabee 2-Ply Acid-Free Bristol
 Vellum Board, White

To control some colors, such as bright yellows that can be very intense, Wollam lightens them by first applying a layer of white under them. He aims for thick pigment saturation and works with a heavy pressure to fill the grain of the paper.

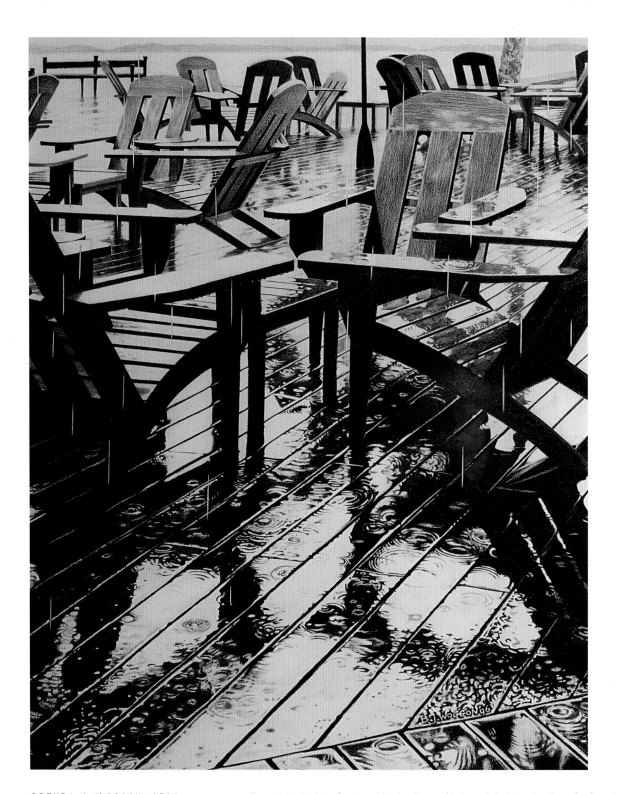

BRENDA J. WOGGON, CPSA
CPSA AWARD FOR EXCEPTIONAL MERIT
Scattered Showers
30 x 24 in. (76x61 cm)
Surface Used: Windberg Art Panel, White

There is no black in Woggon's painting. She mixes indigo blue, dark brown, and sepia for the dark areas, with mostly Tuscan red, sienna brown, and various grays for the chairs. The rain drops were created with an electric eraser and erasing template.

I'm a vision junkie—fascinated by the dance of light and shadow, the glow of reflected colors, the sparkle of water. I can be inspired by a landscape or a face, but what I see at that moment needs to be put down on paper. I am a realist; it's taken me time to feel OK about that since the artistic stereotype is to be free and spontaneous. Colored pencil is such a slow and deliberate way of working—it's not just a drawing, it's a commitment! I work with colored pencil because of this; there is nothing on that paper unless I planned and put it there.

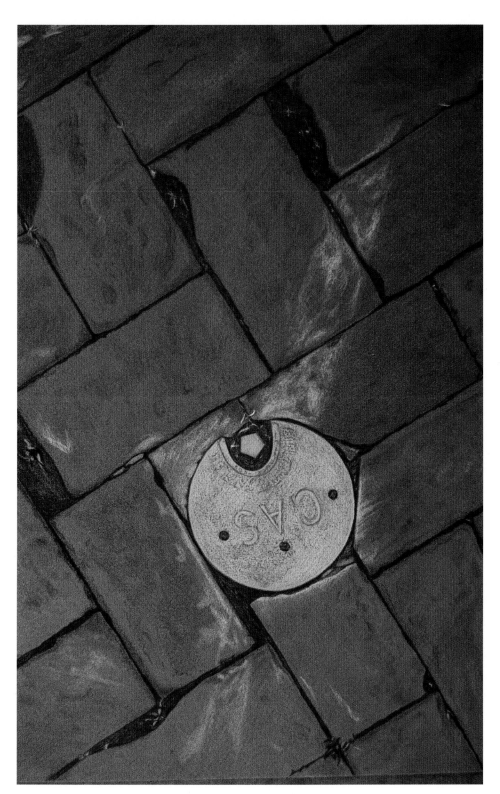

ANDREA L. ZINKUS
Old Town
13 x 9 in. (31x24 cm)
Surface Used: Canson Mi-Tientes Paper, Dark
 Gray

Zinkus chooses a dark gray paper to act as an undertone that will enhance the old brick look. She removes pigment as little as possible because it is difficult to match new color blends over those that have been lifted.

While in Alexandria, Virginia, I visited an area called Old Town. I found you needed to walk with your head down in order to navigate the old, bumpy, brick walkways. And there it was—a bright yellow gas meter surrounded by red bricks. The contrasting colors, diagonal design of the bricks, and roundness of the meter provided the strong composition for this painting.

KENNETH L. ZONKER
It's a Matter of Choices
29 x 23 in. (32x58 cm)
Surface Used: Crescent Cold Press
Illustration Board #110, White

Zonker builds to dark colors slowly in a crosshatching pattern using small circular strokes. The heavyweight, slightly textured board he prefers allows for dense layering and significant changes. Using an electric eraser, he whittles the eraser tip to a point to create small hits of light or cuts it flat to make straight lines.

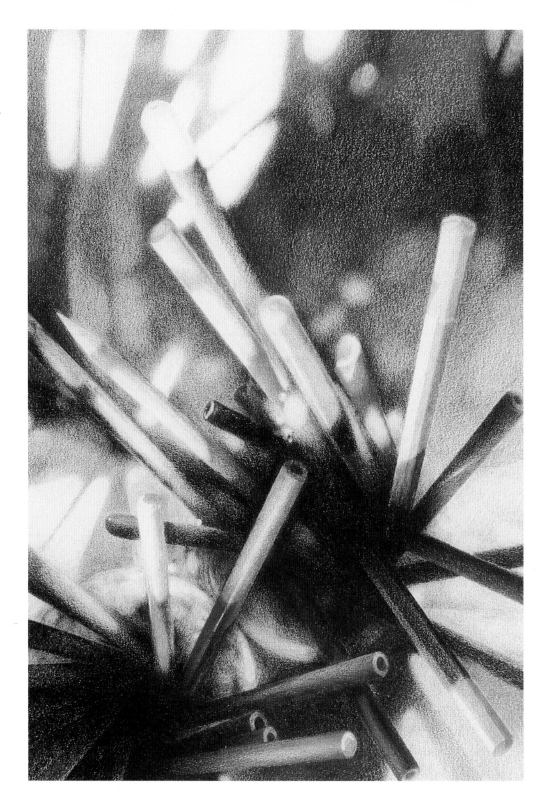

It's a Matter of Choices is a straightforward drawing following very traditional guidelines. Its uniqueness comes from the subject itself, its ambiguous environment, and the rather dark mood portrayed. Many sticks and lines thrust into the air and an indistinguishable background of muted colors repeat the pattern. Pattern and texture, shadow and light—regardless of tools, techniques and media, my goal is a balance of formal elements to create a special mood or environment for simple and utilitarian objects.

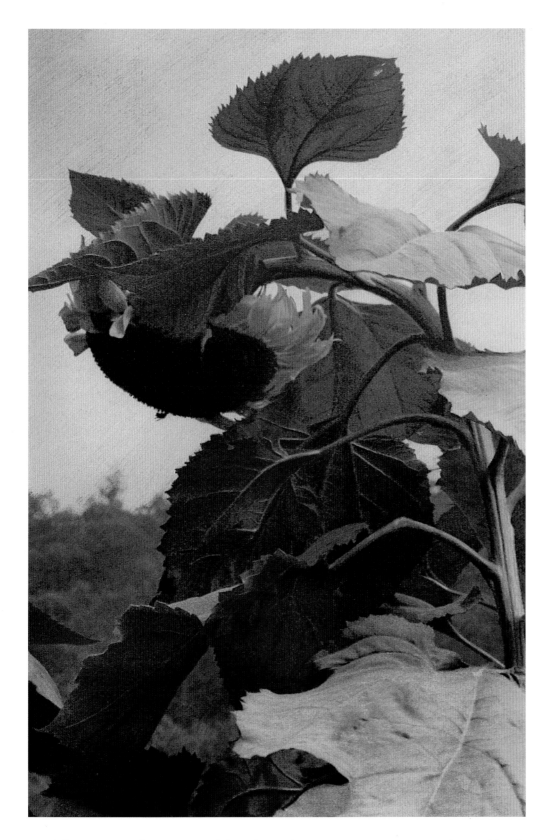

NANCY HUGHES
SANFORD PRISMACOLOR AWARD
OF EXCELLENCE
New River Sentinel
16 x 10 in. (41x26 cm)
Surface Used: Laser Paper, White

Hughes burnishes the many layers with
heavy pressure and sprays with work-
able fixative. She will reapply color to
the burnished area if necessary. For
the mottled look in the leaves, Hughes
applies mineral spirits to a small brush
and lightly lifts, dabs, and blends tiny
sections.

Decidedly, the style I use for any given work depends upon the best way to present my emotional intent of the sub-
ject matter. I chose to portray *New River Sentinel* with photo-realism so that you would first perceive that you
were looking at a photograph—only to be surprised that it was a painting. To produce a photo-realistic painting, I
pay a great deal of attention to details: every vein in every leaf; all the folds, ridges, curves of the subject; and not
just the local colors, but those reflected and cast by shadows and sunlight. Details don't bother me—I love them!
The more complicated the subject, the more intrigued I become.

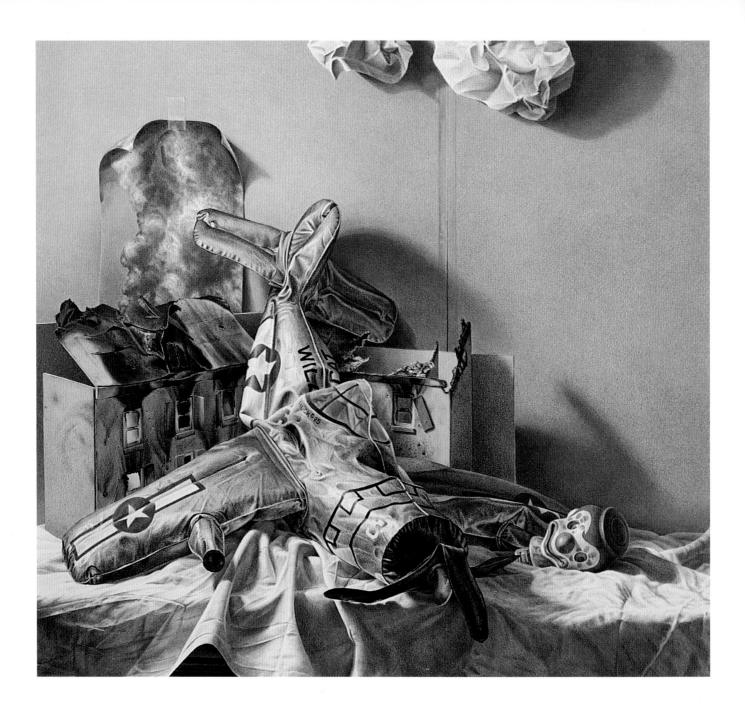

RICHARD W. HUCK
Still in Conflict II
23 x 25 in. (58x64 cm)
Surface Used: Arches 260 lb. Hot Press Paper,
　White

Once Huck builds several layers of color with very thin, hard-lead colored pencils, he introduces the softer, wax-based pencils. Both types of pencils are continually used until the desired color or texture is achieved. There may be a dozen or more layers of complementary and neutral colors in some areas.

It's not the techniques I employ that set my artwork apart. There are many skilled artists working in the same vein; it is the individual's philosophies and ideas that separate us. My studio contains numerous objects, collected over the years, that often act as catalysts for deeper thought. I construct environments for some of these objects and work directly from them to create "stills." While I use objects, such as toys, symbolically to get my ideas across, giving explanation to this symbolism can disrupt the viewer's interaction with the work and destroy a connection that was attained. In many cases, the title will assist in this connection.

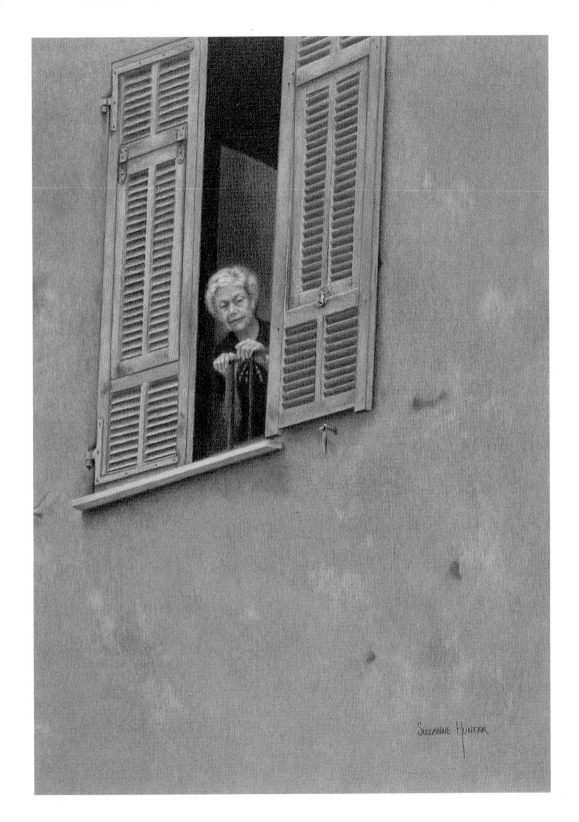

The idea for this painting came from a trip through France. I was struck by the feeling of desolation and solitude in the small French towns as evening descended and the windows became covered with shutters. I snapped a photo of this elderly woman looking from her window. To enhance the feeling of isolation as darkness approaches, I placed her high in the picture plane and left much of the empty space below her. Her expression is one of submission. Age and/or illness have reduced her to merely being an observer. She is alone. Thus, I named the picture *The Widow*.

SUZANNE HUNTER
The Widow
15 x 11 in. (37x27 cm)
Surface Used: Alphamat, Gray #8470

To support the somber theme, Hunter used a gray surface allowing it to show through the ochre of the stucco. She began working with short, overlapping, diagonal strokes then blended them with a tiny, continuous circular movement.

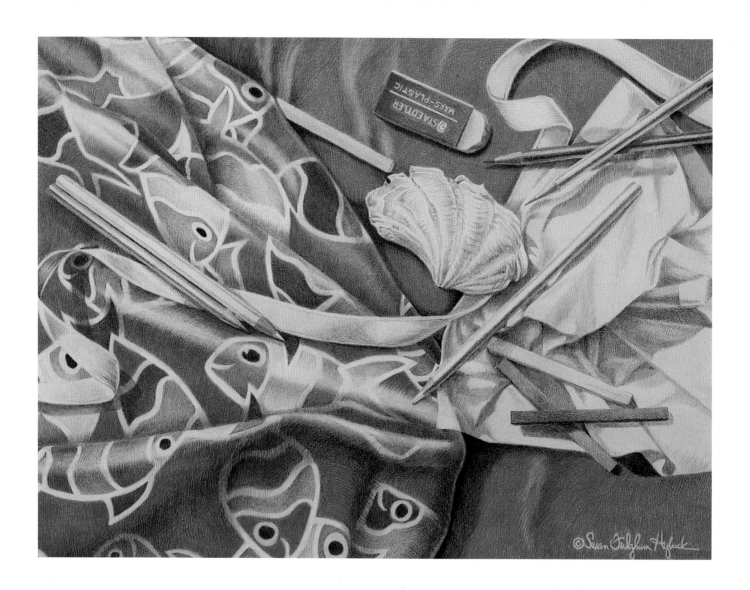

SUSAN FULGHUM HYBACK
Smiling Fish Still Life
16 x 22 in. (41x56 cm)
Surface Used: Rising Museum Board, White

Hyback combines crosshatching, impressionistic line-work, and sgraffito to create textures and indicate movement. She applies as much layering to the saturated colors as possible, being careful not to crush the surface of the soft paper.

This cheerful piece of fabric—with its strong saturation of primary colors and reflections of adjoining hues—inspired me to paint *Smiling Fish Still Life*. With the seashell as the center of interest, I constructed a still life with the intent of keeping your attention within the painting—purposely arranging each object to lead your eye around and across the surface. The placement of the pencils, art sticks, and folds serve to lead you back to the focal point. I wanted the details to show but not to override the synergism of the work. The color reflections throughout the piece brought unification to the many strong elements.

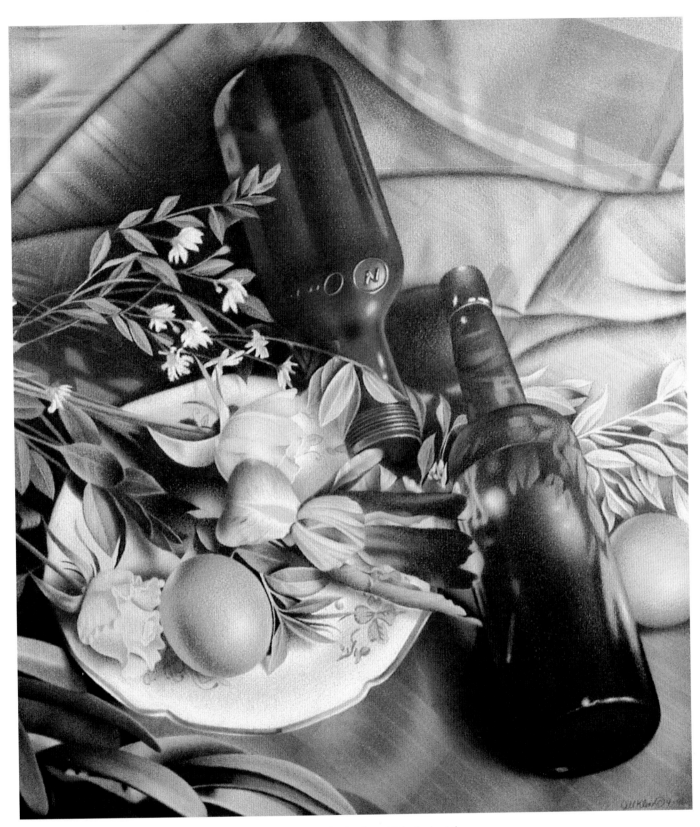

The colored pencil is the only medium I've worked with that does exactly what I want it to do. I get the detail I want and the exact color that I imagined. I've been asked how I "smear" my colors to cause them to look so soft—some people think that a particular paper will cause this to happen. It makes me smile. I simply don't like abrupt or hard shadows. Most areas of this painting have a smooth, shiny finish. I have never made a specific effort to burnish, yet this is what results in my effort to eliminate the speckles of paper showing through the layers. When the paper won't accept any more pigment, I'm done.

JILL L. KLINE, CPSA
A New Leaf
32 x 30 in. (81x76 cm)
Surface Used: Canson Mi-Tientes 75 lb. Paper,
 Orchid

Creating slight ripples in color and shading kept the fabric in the right-hand corner from looking like a pattern on a flat surface. Kline keeps this still life fresh and moving with a balance of vibrant colors and varied values.

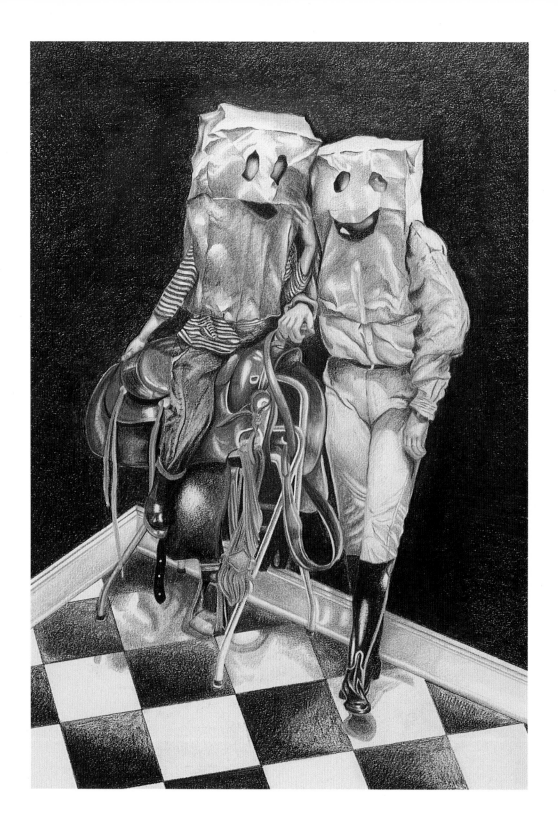

BLAIR JACKSON
Bag Ladies
31 x 25 in. (79x64 cm)
Surface Used: Crescent Cold Press Illustration
 Board, White

Starting from the upper left-hand corner,
Jackson methodically works diagonally, com-
pleting one small area at a time, to the bottom
right. Some areas are left coarse with pigment,
while others are blended smooth with a color-

With each successive work, my biggest effort is in the manual skill of drawing. Conceiving the idea and overall composition comes relatively easy since I derive stimulation from daily life. My children are the subject matter for the majority of my drawings. Although I rejoice in the beauty of my kids, I am most interested in the peculiar situations that I find them. It was a rainy day, and this was the idea that kept my daughter and her cousin busy. That capriciousness from complete normalcy propels me to capture the fleeting instance. I like to evoke a feeling of solitude, even with drawings that include multiple fig-ures, creating the mood that each person is an island.

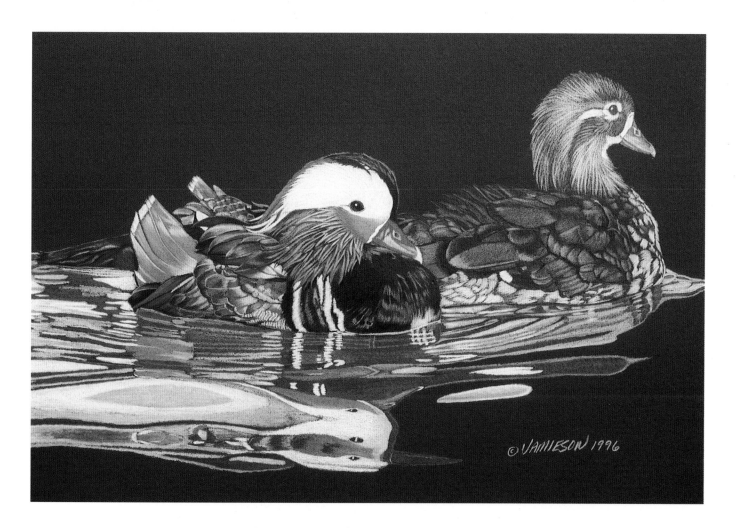

As a professional animal photographer and wildlife artist, I feel an obligation to portray my subjects truthfully—with appropriate habitat, behavior, and anatomical accuracy. One day, while feeding a variety of domestic and wild indigenous ducks, an exotically colored, delicate little duck flew into the crowd. He was so small; so arrogant. I knew from studying field guides that he was a Mandarin Duck, the oriental version of the North American Wood Duck. Beauty in nature does not have to be contrived or complicated—there is dignity, truth, excitement, and surprises to be found if you just take the time to look.

JUDITH L. JAMIESON
Mandarin Romance
10 x 14 in. (25x36 cm)
Surface Used: Strathmore 400 2-Ply Museum
 Board, Black

While staying true to the subject, Jamieson adds artistic interpretation in the abstracted reflections and vivid colors. This painting is a composite made from two photographs.

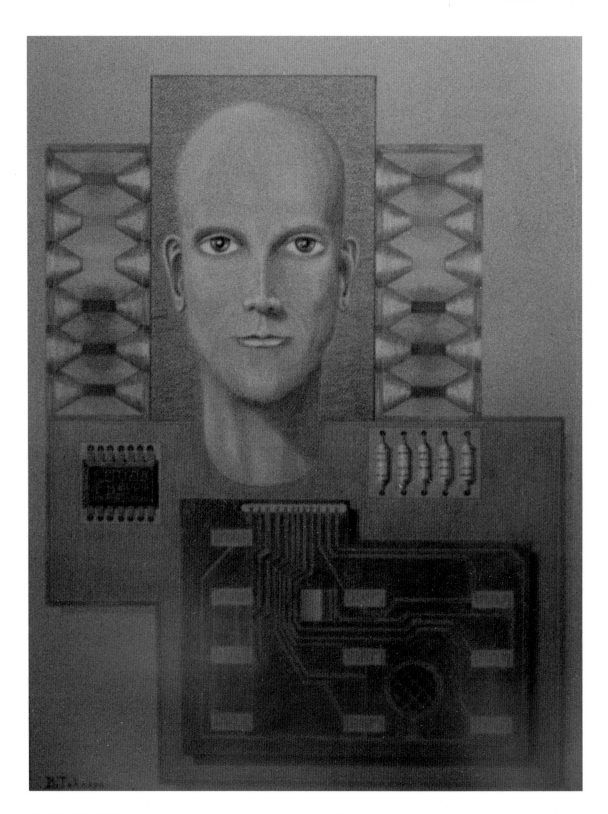

BRUCE JOHNSON
Citizen 2000
25 x 19 in. (64x48 cm)
Surface Used: Canson Mi-Tientes
75 lb. Acid-Free Paper, Egg Shell

The clean geometric shapes in "Citizen 2000" were drawn with the use of drafting templates. Johnson uses a limited palette of hues in red, green, blue, yellow, and gray. His reference materials are limited to his imagination and a small computer chip for inspiration.

Technology and its effects on people and nature is a motivating factor for me. *Citizen 2000* is the result of observing today's global technological revolution—how it alters our perception of our individuality, the subtle manipulation of our "humanness," and our ultimate dependency on it. My approach to conveying these underlying ideas is through simplicity. I'm an artist because I like exploring the parameters of the creative self. My work is not generic. It isn't dependent on how cute Fluffy the family dog looks draped over the living room chair, or on a cleverly arranged still life, or an interesting weathered piece of anything. Its intent is to take you out of the realm of established frames of reference.

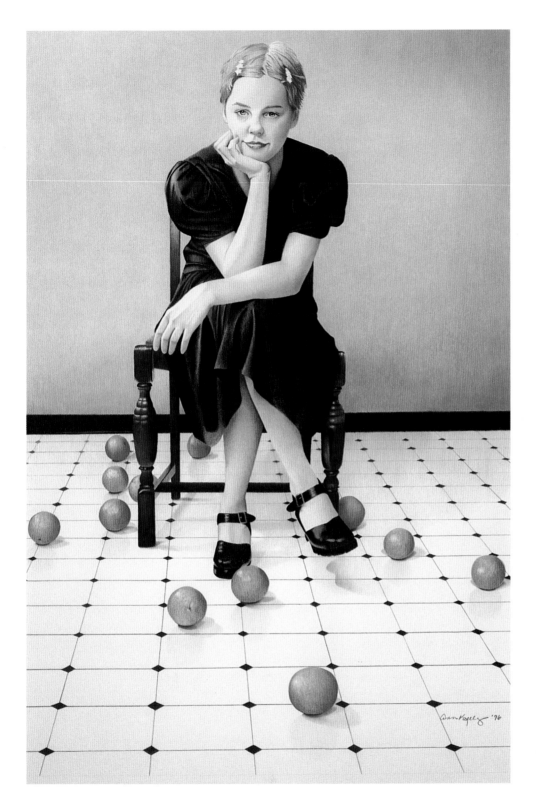

Since I make my living as a portrait artist, I rarely get to do art that is just for me. But at least once a year, I stop work to "play" in order to create a piece for the CPSA International Exhibition. *Not Everything is Black and White* is one such piece. I chose this girl as she seemed to be in that transitional "nowhere land"—no longer a child, not yet a woman—that age of mercurial changes in mood and heart. I strongly believe that life is shades of gray and try not to see things as black or white, right or wrong, good or bad. This girl, neither child nor adult, captures the ambiguity of life. It is a statement to all of those who continue to put everything in just two boxes.

ANN KULLBERG, CPSA
Not Everything is Black and
 White
33 x 25 in. (84x64 cm)
Surface Used: Rising Stonehenge Paper, White

This seemingly simple composition makes a powerful image. Kullberg allows some serendipity by dumping a bag of oranges on the floor (she only had to reposition one of them). The majority of this work is done with vertical strokes and with scumbling used for the skin tones.

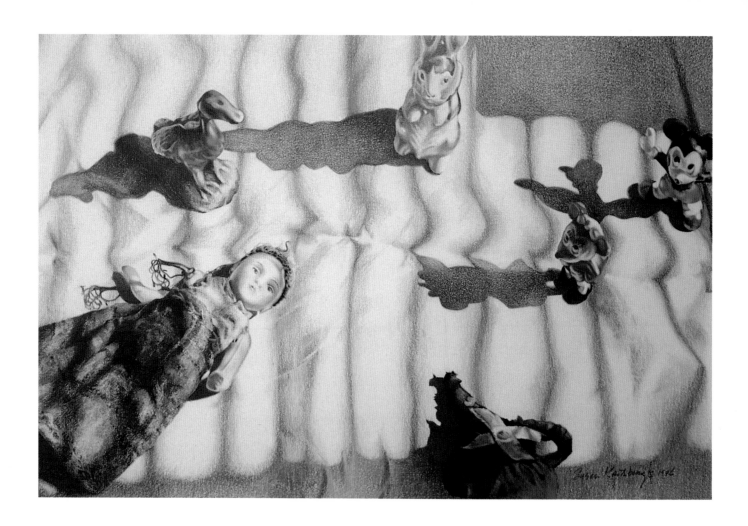

SUSAN KRITZBERG
Scattered Memories
14 x 20 in. (34x50 cm)
Surface Used: Crescent 300 Cold Press
 Illustration Board, White

Kritzberg completes each figure before working
on the background. She then sprays light coats
of fixative to protect the finished areas while
she completes the rest of the painting. Kamar
varnish is applied as a finishing coat.

From inception to completion, *Scattered Memories* offered challenges on many levels. Combined, all
the objects in this still life could fit in the palm of my hand. My initial approach was to emphasize their
unique qualities in a larger-than-life format. As I worked with the arrangement, studying the relationships
that formed, I realized that a variety of contrasts would just as effectively produce a dynamic, thought-
provoking image. The long cast shadows of the figures coupled with the rhythmic pattern of the venetian
blind, integrates the relationship between the positive and negative shapes in this strange little landscape.

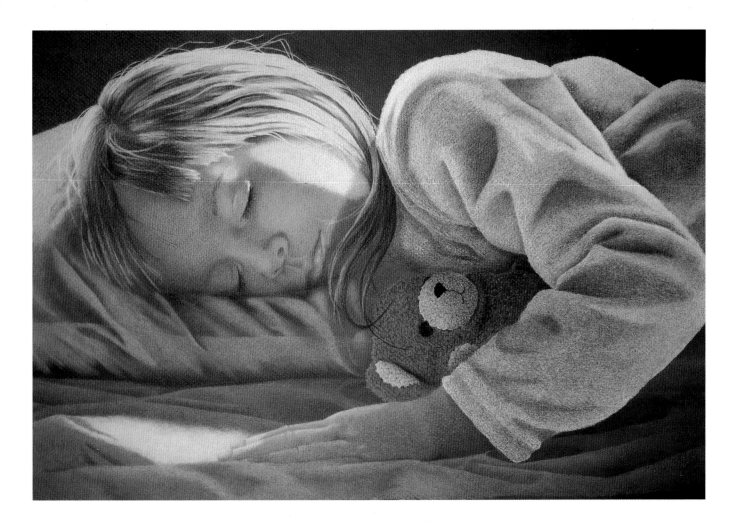

I work exclusively from photographs. Children are far happier playing while I photograph them for a half-hour than having to sit still for a portrait drawing. Since I emphasize light in my paintings, getting an unusual light placement in the photographs is most important. I chose this composition for *Sweet Dreams* because of the dramatic light patterns. The light coming across the young girl's face and down to her hand gave me a special feeling of connection with the child.

DIANE LAUZEN
Sweet Dreams
20 x 24 in. (51x60 cm)
Surface Used: Canson Mi-Tientes Paper, Plum

To get the fine tonal application in this painting, Lauzen varies short diagonal strokes with small circles. While she allows the color of the paper to show through the layers of pigment, she counterbalances its plum-colored surface by adding dark green to the shadows of the flesh tones.

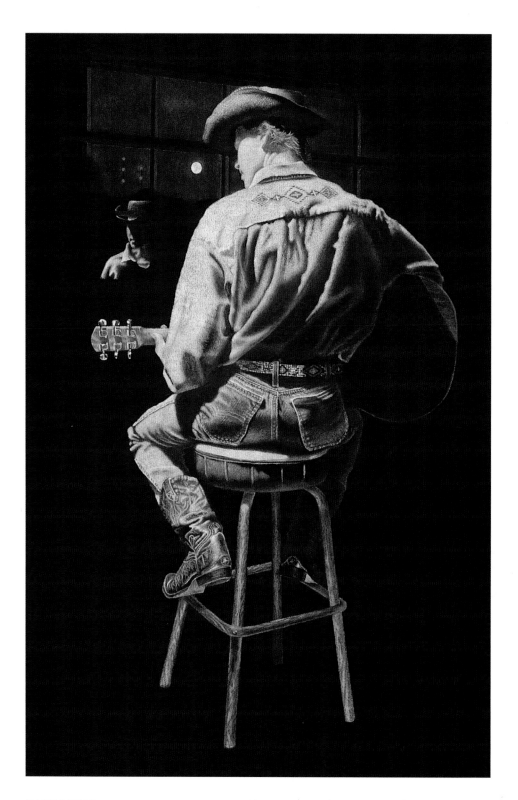

MARY LEKAN
Late Night Tunes
20 x 15 in. (51x38 cm)
Surfaced Used: Letramax Illustration Board,
 Black

Since the tooth of Letramax illustration board
inhibits building as many layers of pigment as
other surfaces, Lekan visualizes the effect each
color will have before she applies it. This work
is a study in complementary colors, using blues
and oranges subdued by grays and browns.

After many years of touring as a professional musician, I was having a change of heart regarding my
future. Those late nights in smoky bars were taking their toll on my health and lifestyle. I returned to
college to attend art classes and tried all the media available. I couldn't mix paints as accurately as I
wanted, my skills at airbrushing weren't as exact as the tool demanded, and my watercolors looked
labored. It wasn't until I discovered colored pencils that I was able to layer colors and obtain precisely
the shades and tones I wanted. I love working tight and sharp, so the fine point of a pencil is the perfect
tool for me.

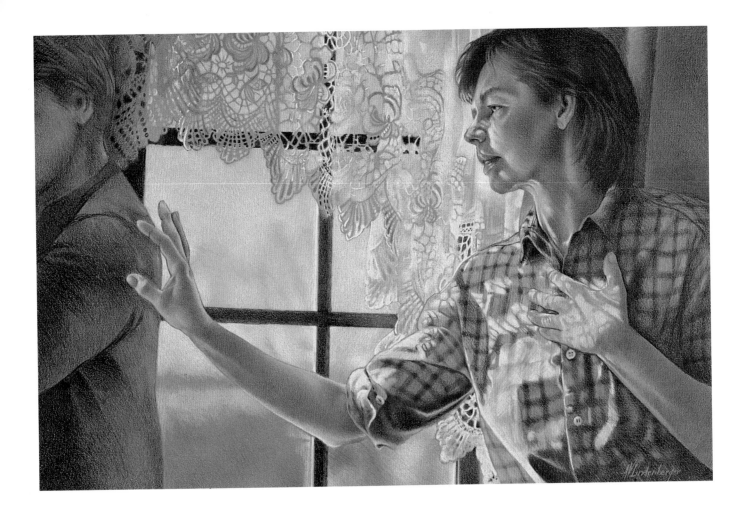

This painting represents those times in our lives when something we desperately want—a relationship, creative breakthrough, good health, or feeling of completeness—seems just beyond our reach, and try as we might, we are powerless to achieve our goal at that moment. I like the expression on the model's face and her outstretched arm. Her expression is intriguing—not happy, not sad, but earnest. I did not want to give the second figure too much importance and intentionally kept it as nonspecific and shadowy as possible so that viewers could interpret for themselves the meaning of this scene.

AMY LINDENBERGER
Out of Reach
13 x 17 in. (33x48 cm)
Surface Used: Crescent Acid-Free Mat Board,
 Gray-Violet #1595

Lindenberger chooses colors to complement the gray-violet of the drawing surface. The color scheme consists of four analogous colors: blue, blue-violet, violet, and red-violet; with their complements, orange and yellow-orange, used to modify and balance them.

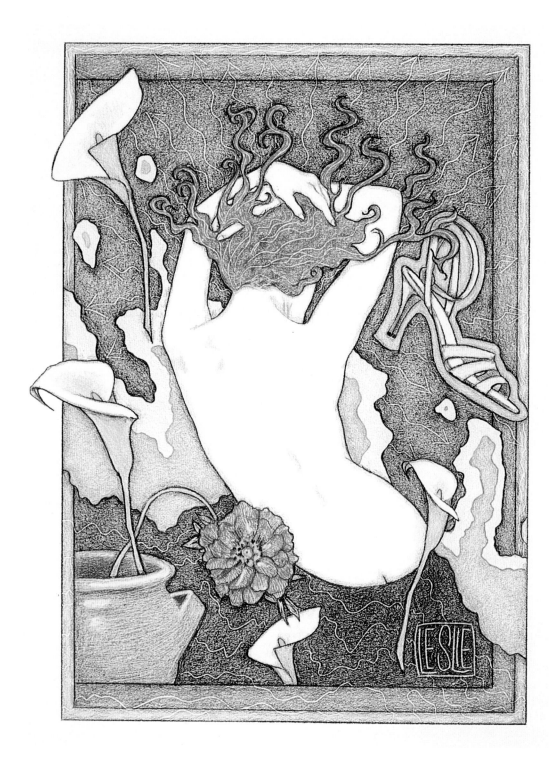

LESLIE ROBERTS
N u d e w i t h S h o e
14 x 11 in. (36x28 cm)
Surface Used: Strathmore 3-Ply Bristol Board,
 Kid Finish

Leslie created the impressed lines in the hair
and background with a regular burnisher used
for transfer letters. She uses a battery operated
eraser or drafting tape to remove pigment and
sprays the final work with Cascaux fixative
because it doesn't influence the colors.

Nude with Shoe is a very transitional piece for me and was created during a personal upheaval in my
life. This subject appealed to me at a time when I was having self-image problems and needed to
explore the sensual side of my nature. The floating look of the objects is common to most of my work.
Shoes and flowers are also reoccurring themes because I consider them quite feminine. "Message" is not
a word I associate with my artistic process as much as "mood" or "feeling." It always interests me, how-
ever, that others can tell things about me from what I create. So, although I do not consciously send a
message, somehow one is being received.

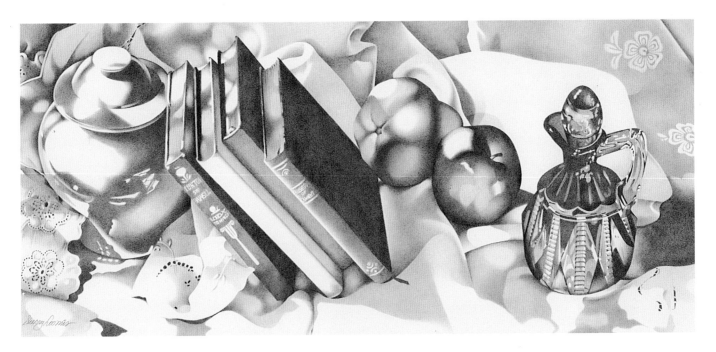

The visual combination of gradating dark and light shapes in this piece is what appeals to me. It is my first attempt to define the subject using only values and so represents a departure from my other colored pencil artwork. I begin all my work the same way—by executing the entire piece in gray values. I would normally apply color over this value painting; however, I didn't want color to overwhelm value. So I chose to celebrate the full range of darkness and light in *Good Fortune*.

SHERRY LOOMIS
Good Fortune
15 x 34 in. (38x86 cm)
Surface Used: Strathmore 4-Ply Bristol Plate,
 White

The difference between the lightest and the darkest areas is the number of gray layers Loomis applies, not the amount of pressure she applies them with. Loomis uses an extremely light touch and very sharp pencils to achieve this fine tonal application.

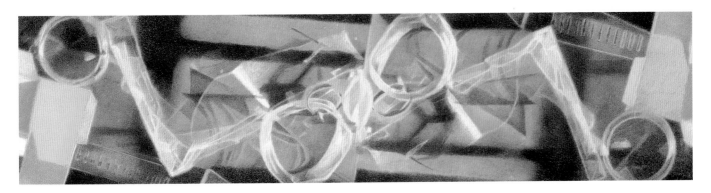

Seneca Shortstop is a march of animated plastic bottle caps, cellophane wrappers, and cardboard box parts. I cannot offer any solid reason for my long-term fascination with these mundane and disposable objects. I suppose it's because they are not normally considered worthy of spending weeks or months drawing. The goal here is to produce an illusion of movement by the placement of these objects. This painting is suffused with a light of yellow ochre and bronze, colors I never would have chosen before working with colored pencils. This medium has been of direct importance to my creative style because of the discipline it imposes and its vast expressive possibilities.

LEE SIMS, CPSA
Seneca Shortstop
13 x 30 in. (32x75 cm)
Surface Used: Acid-Free Etching Paper, Brown

Using her many photographs of the objects, Sims makes several collages to work out compositional decisions. She creates movement with strong diagonal shapes, repeated patterns, and spatial rhythm. The artist used over twenty hues to create this simple color scheme of beige, charcoal, and white.

JUNE S. LEWIS
Rosa Is Three!
15 x 21 in. (38x52 cm)
Surface Used: 4-Ply Museum Board, Cream

"Rosa Is Three" incorporates replicas of a
child's drawings made before her third birthday.
Lewis transferred the drawings with an opaque
projector then composed the birthday theme
around them.

A "prop" found around the house is generally a starting point for my art. Then comes a page of free asso-
ciation—words and phrases written on lined paper. This can take many days. As the list gets longer, the
creative juices begin to flow and I start to sketch. I draw one object at a time and end up with a pile of little
pieces of paper. These bits and pieces are moved around on my board with the help of an opaque projec-
tor—an ideal compositional tool that saves time and erasing. I change my mind a lot and finally transfer the
sketches to my drawing surface. I paint what I am familiar with. I paint what I love, and I love what I paint.

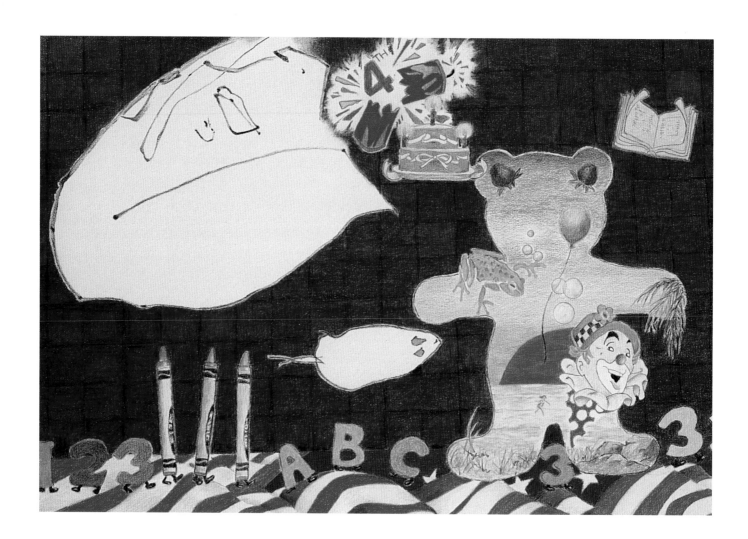

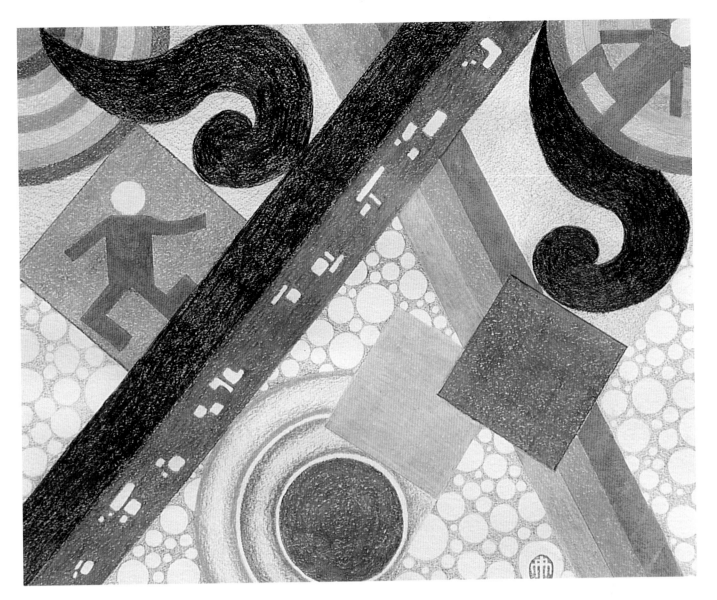

My artistic goal is not for commercial success; I work mainly to please myself. *Two Jazz Singers* is a visual expression of harmony, syncopated rhythm, the joy, and freedom of improvised jazz. I like bold contrasts and arresting combinations. The contrast between the bright, strong colored areas and the more subtle background treatment corresponds to the musical rhythm of my old love, New Orleans jazz.

NICOLE NEILSON
Two Jazz Singers
16 x 20 in. (41x51 cm)
Surface Used: Strathmore 140 lb. Acid-Free
 Watercolor Paper, White

In this contemporary drawing, Neilson suggests musical instruments, notes, and records through the use of geometric shapes. She applies heavy pressure with the back of a plastic spoon to burnish layers and employs various strokes in the work.

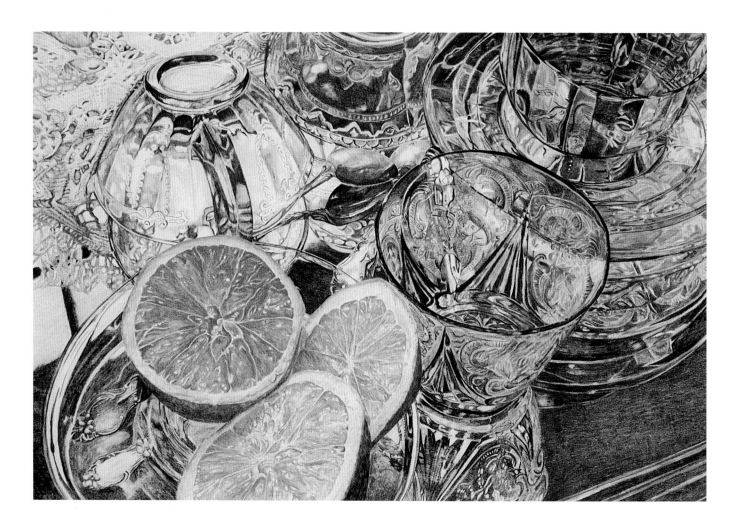

CYNTHIA LOCK PEANICK
Reflections
28 x 32 in. (71x81 cm)
Surface Used: Lanaquarelle 300 lb. Hot Press
Paper, White

Peanick feels that each piece must have the entire value scale within it or it will suffer. She maintains the white of the paper in the lightest areas. The darkest sections are layers of violets, blues, grays, and greens. Twenty-eight hues were used in this seemingly simple color scheme.

The transparency of glass has always fascinated me, and rendering it is an exciting challenge. However, in this piece the transparent quality became secondary. It was the reflective and the refractive properties of the glass that appealed to me the most—its gem-like quality bending and moving the light. I constructed and photographed this still life using several arrangements, viewpoints, and lighting situations. Because of its dramatic effect and its tendency to promote very dark values, I chose natural backlighting for this composition. The addition of oranges provided a warm glow within the cool of the greens.

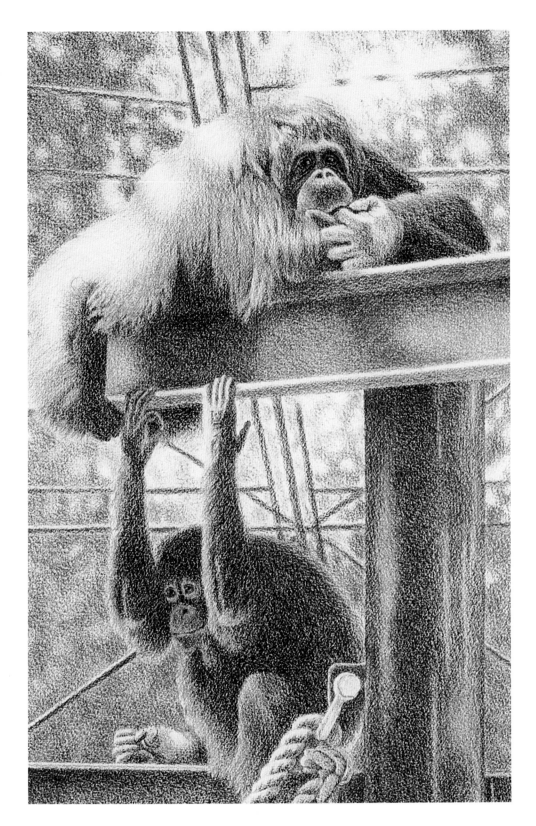

RUTH A. PERKINS
Orangutans—Phoenix Zoo
27 x 30 in. (71x81 cm)
Surface Used: Arches 300 lb. Cold Press
 Acid-Free Paper, White

Perkins staples heavy watercolor paper to
stretcher bars for a taunt, bouncy surface
to work on. She works with the texture of
this paper to give a slightly out-of-focus
look to the subjects and uses various
strokes to avoid any linear qualities.

I don't remember a time when I wasn't an artist. My father is an artist who frequently encouraged me to draw
and paint when I was growing up. I'm motivated by form and color and enjoy the challenges in producing rep-
resentational artwork. My zoo series stems from my love of animals and concern over environmental factors
responsible for the loss of animals and their habitat. I want to get images of these magnificent creatures in front
of the general public to increase their awareness of this problem.

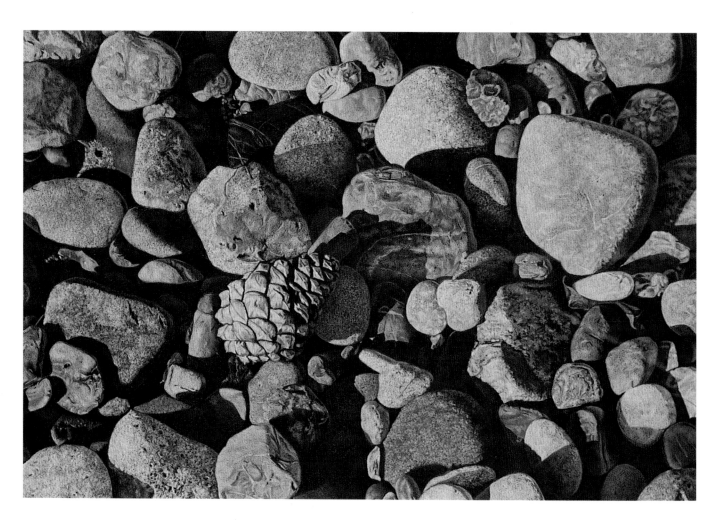

JAMES K. MATEER
On the Rocks
27 x 36 in. (69x91 cm)
Surface Used: Arches Acid-Free Paper, Black

Using black paper, Mateer is forced to work the lightest tones to the fullest in order to contrast with the solid black shadows of the rocks. He paints hard, soft, and lost edges to add depth to the rock layers.

Although my work is considered highly realistic, I generalize color and texture so there is greater clarity in the finished art than in the reference photograph. Subjects such as this give me the opportunity to exploit subtle color variations and intricate textural surfaces. I enjoy capturing sections of nature in what I refer to as "full field" (i.e., areas of repetitive objects that fill the entire space—layers of fall leaves or pebbles on the beach). My major tenet is "Value is king; color is play." While I am never concerned with exact color interpretation, I am as literal as possible when it comes to value.

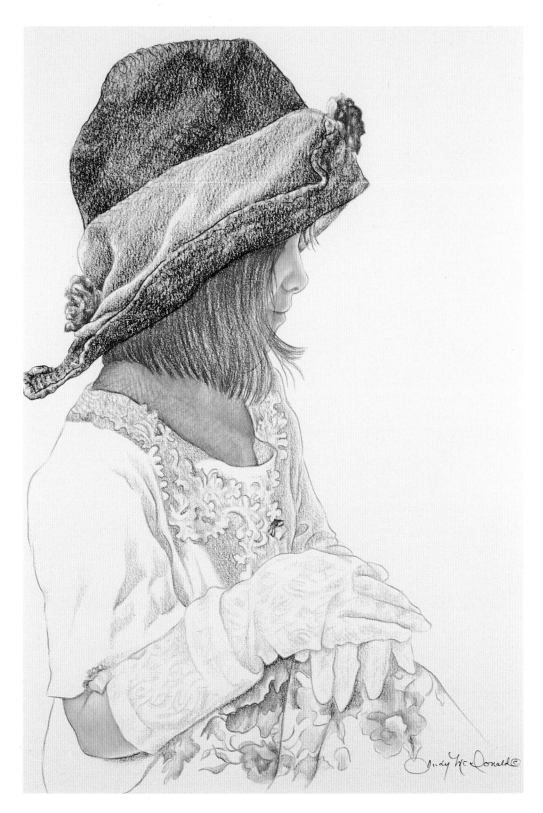

To create my colored pencil paintings, I use models. Some of my models have been working with me since they were toddlers. They are very comfortable posing for me and think of it as playing "make-believe." They bring their own costumes and props or select some of mine. They show their own personality and creativity by the selections they make. As soon as they are in costume, they begin to change; they become someone else. I photograph them as they enter their own world and forget my presence.

JUDY MCDONALD
A Perfect Lady
16 x 12 in. (41x31 cm)
Surface Used: Rising Acid-Free Stonehenge, White

After a monochromatic layer is applied, McDonald uses small strokes and circles to add skin tones. These are then blended with a cream or white pencil. The simple composition emphasizes the daintiness of the model.

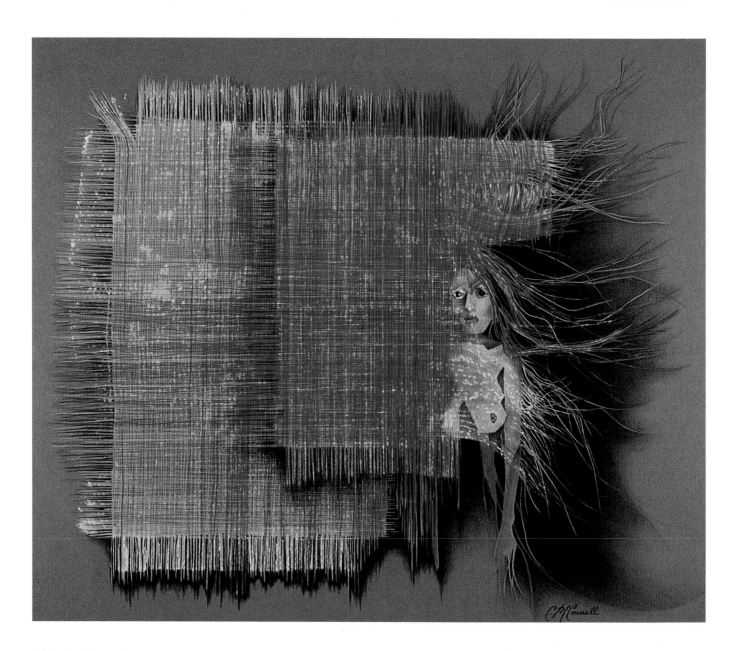

CARLA MCCONNELL
Frazzed
28 x 32 in. (71x81 cm)
Surface Used: Crescent Acid-Free Mat Board,
Dark Green

McConnell chooses a dark green board to contrast the reds in the painting. She lightens part of the surface with bleach so the red colored pencil pigments do not become drab on the green paper.

Having a background and interest in Anthropology, I am constantly inspired by the diversification of cultures. The use of multicultural elements while exploring human emotions, relationships, and issues continues to pervade. Artists have a responsibility to interpret life, not just imitate and record it. More and more, I favor strong visual statements and prefer to work in a related series. *Frazzed* is a direct visual outcome of my conversations with women—it is simply how many of us feel, or have felt. It seemed natural to incorporate woven textures with human form for this disintegrating piece.

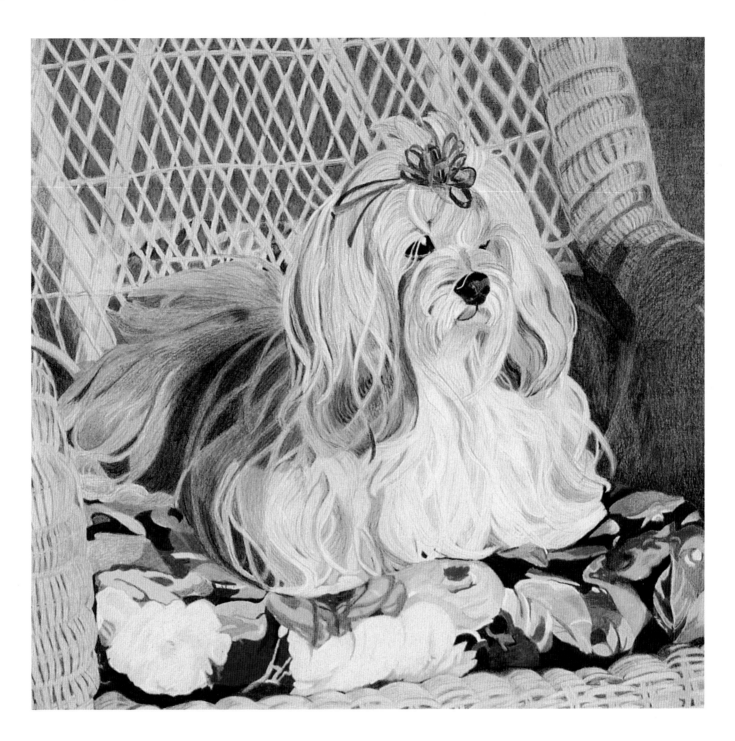

I don't have many set ways of doing things to help or hinder me. I have a fairly basic plan of attack—begin with the darks and progress to the lights. I first do the parts I enjoy and work on less interesting areas after I have a bond with the painting and an ambition to finish it. My only color theory is to mix color until I am happy with what I see. Very interestingly, I find that using colored pencils is more difficult than oils. It is harder to mix colors, and detailing is more exacting. The only procedure impressed upon me in using colored pencils is to always keep a sharp point. I break that rule and work quite well with a dull pencil.

LOU ANN MCKINNEY
Lhasa Lady
18 x 18 in. (46x46 cm)
Surface Used: Crescent Acid-Free Mat Board,
 Ivory

To frame the focal point, McKinney adds the colors of the cushion above and around the dog. Darkening the green background defines the wicker pattern and brings the subject forward.

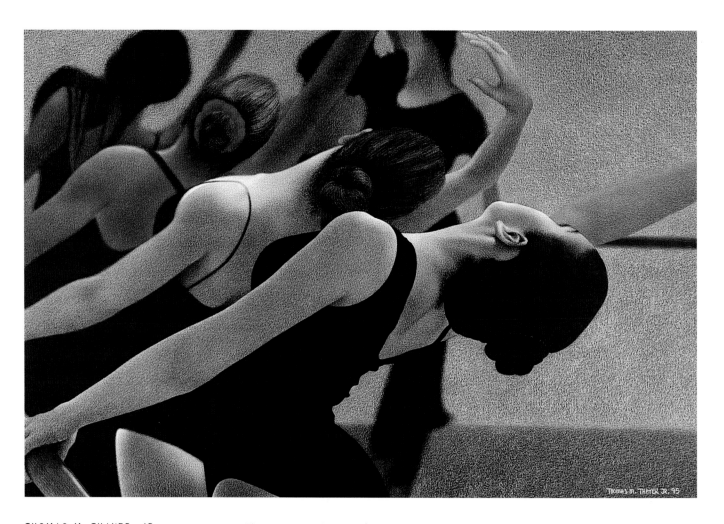

THOMAS M. THAYER, JR.
The Rehearsal
20 x 30 in. (51x76 cm)
Surface Used: Crescent Acid-Free Mat Board,
 Black

Thayer's limited palette of warm browns and
grays is sparked with one focal point of color.
He implies the black leotards, shadows, and hair
with the untouched surface of the black board.
This omission of color provides the darkest value
and saves a considerable amount of time.

That exciting combination of innocence and sensuousness is difficult to express in a painting.
I am always inspired by soft lighting and complex compositions. The subtlety of shadow and light on these ageless and timeless ballet dancers accentuates the flowing lines of their fleeting pose. I try to represent the most realistic image in my paintings with the least amount of detail. I want just enough realism to stimulate your eye into filling in the rest of the information. It has taken me many years to see things differently than other artists, and to learn what I can leave out of a work to make it look more real than it is.

KATHLEEN E. MCLEOD
Sunday Brunch
9 x 12 in. (23x29 cm)
Surface Used: Canson Mi-Tientes, White

McLeod employs as many as twenty layers in some sections before she burnishes with a light color. To simplify the design, she eliminated many of the shadows in her reference materials.

Constantly intrigued by the colors and play of light over, around, and through different surfaces, I try to create a "snapshot" of a moment that viewers can imagine themselves entering. Depicting everyday, common objects keeps my art approachable. Colored pencils allow me to work in styles reminiscent of oils, watercolor, or pastels—mediums I have worked in for over forty years.

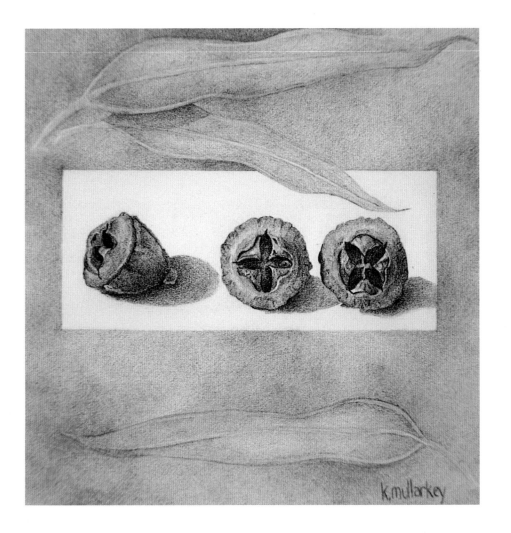

KIMBERLY MULLARKEY
Eucalyptus
11 x 11 in. (28x28 cm)
Surface Used: C. M. Fabriano Acid-Free Paper,
 White

This drawing is part of a series of 4.5" x 4.5" illustrations. Mullarkey chooses this small format to create an intimacy with the viewer. Using the foundation for botanical art, she incorporates design elements in a contemporary style.

The drawing of Eucalyptus came from my interest in nature's "leftovers"—a dried flower pod, seeds, or the brittle branch of a yucca plant. I collect these bits of nature and keep them safe in little boxes. I am amazed at the variety of shapes, forms, textures, and infinite colors that can be found in a small, dried, brown object.

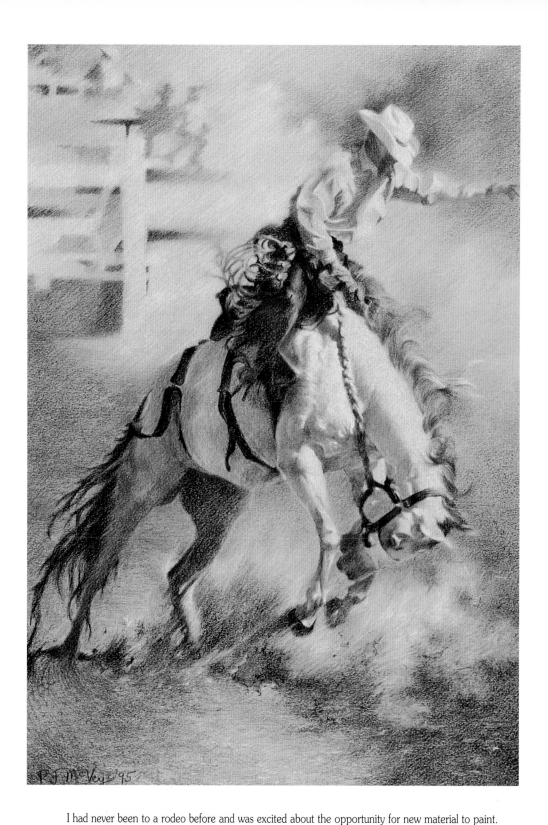

PATRICIA JOY MCVEY
Tehachapi
17 x 12 in. (43x29 cm)
Surface Used: Canson Mi-Tientes (Smooth Side),
Sand

To make colors vibrate or "pop," McVey starts
with a very bright shade of what the final color
will be and then layers darker values over it. She
keeps the background figures two-dimensional
to give an illusion of distance and to keep them
from detracting from the main subject.

I had never been to a rodeo before and was excited about the opportunity for new material to paint.
Unfortunately, by the time I caught on to the action most of the events were nearly over, and I had very
few reusable photographs. I used one picture for the horse and rider, while extracting elements from sev-
eral others for the background. My original attraction was to the horse and rider; but as I worked on the
piece, it became more about dust and violence.

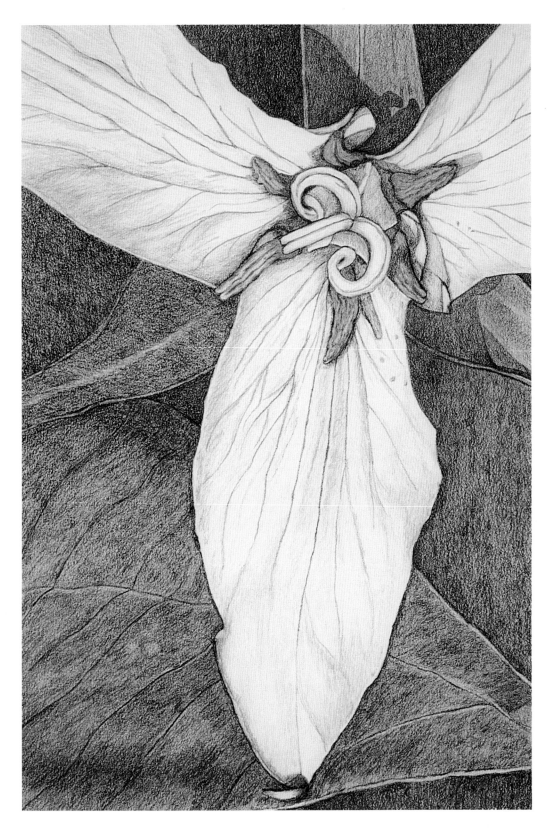

I'm not sure how I came to the place I'm now at in art. It seems to have grown very gradually. As many children do, I loved to draw. When I reached the age that it had to look like the real thing, that love stopped. Then as an adult, drawing once again became the activity I enjoyed most.

LINDA MONDLOCH
Trillium
9 x 14 in. (36x23 cm)
Surface Used: Rising 2-Ply Acid-Free Museum
 Board, White

The strength in Mondloch's illustration is its composition. This straightforward approach of the subject creates a bold design.

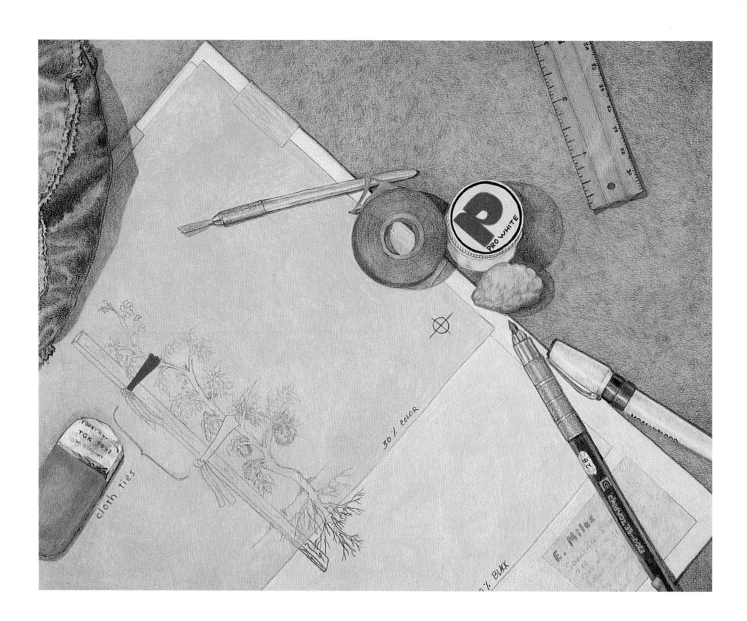

ELISABETH MILES
Back to the Drawing Board
15 x 19 in. (38x47 cm)
Surface Used: Rising 2-Ply Acid-Free Museum
 Board, Gray

Miles works directly from the still life, measuring the objects to ensure a proportionate ratio in enlarging. She adds cast shadows once the illustration is complete.

A college teacher once told me that I did not handle color well; I worked primarily in black and white for the next thirty years. Then I discovered colored pencil. I did *Back to the Drawing Board* as a respite from the tight, persnickety hatching and stippling of illustrations needed for a horticulture textbook. The subject became what was on my drawing board: an illustration of tying tomato plants properly to a stake and the tools used in rendering it. Being motivated by words and phrases, I do not consider a painting finished until I have, what is to me, the absolutely "right" title.

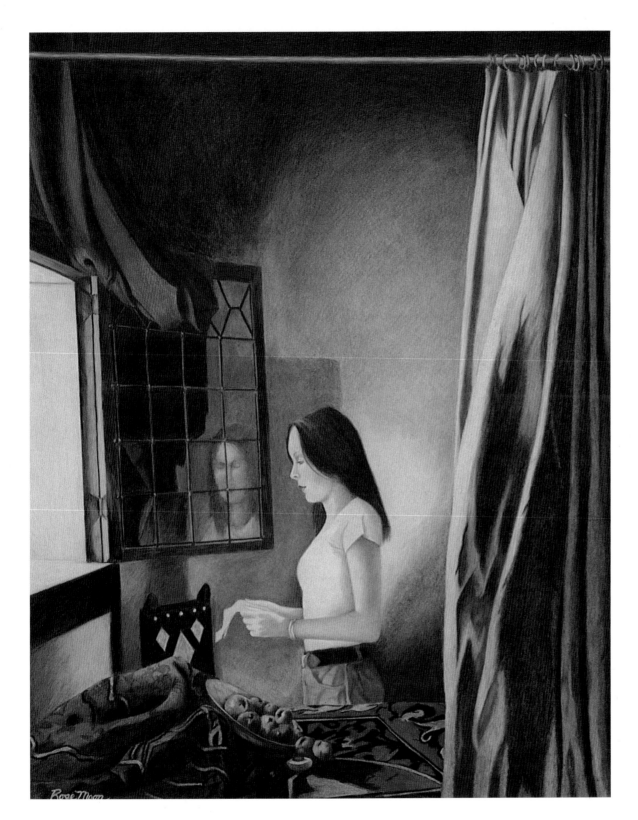

I like the mood of this painting. It captures something about my daughter that is distinctly her. She lives in an old building in San Francisco and dresses much like she appears in the painting. I considered having her talking on the telephone but decided that reading a letter presented more of a mystery and a link to the past.

ROSE MOON
The Letter
23 x 18 in. (57x44 cm)
Surface Used: Strathmore 500 2-Ply Paper,
 White

Working with both a slide and opaque projector, Moon constructs a composite of several reference materials to create this painting reminiscent of Vermeer's work.

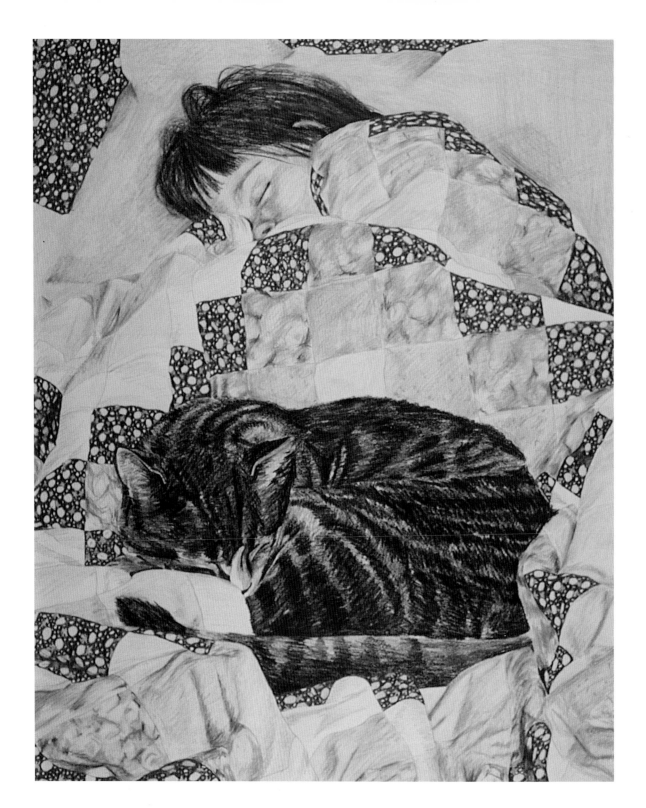

RUTH SCHWARZ MCDONALD
DOCUMOUNTS FRAMING SERVICE AWARD
Naptime
17 x 14 in. (43x36 cm)
Surface Used: Strathmore 90 lb. Hot Press
 Paper, White

Because of the intricate patterns and detail of
the quilt, McDonald decides to use a limited
palette for color continuity. She begins with the
subject and leaves the background for last.

Naptime is a portrait of my daughter as she slept with her cat. I enjoy working with subjects that are very familiar to me, so I use my children, Alexandra and Charlie, as models. The way the quilt created folds that take you from the child to the cat and the fact that you can still see the child's form under the covers made this composition interesting.

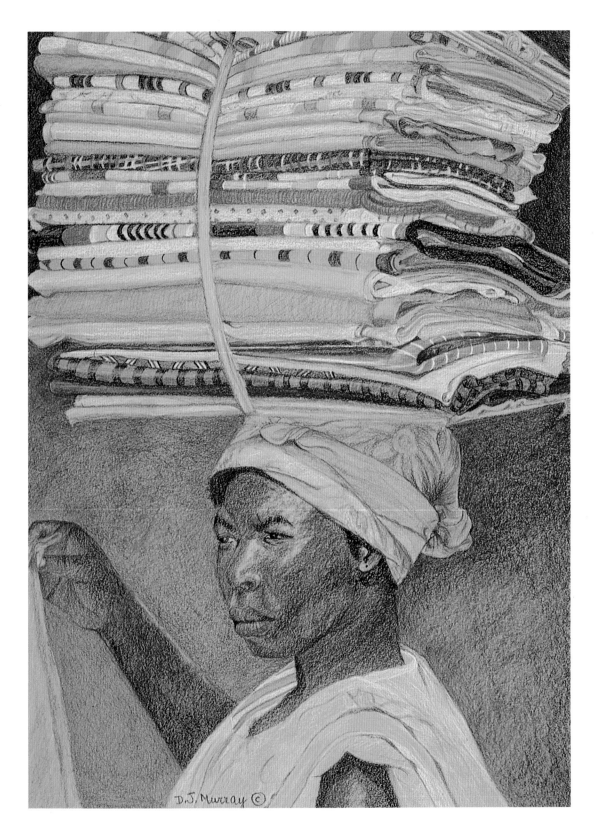

I am motivated by many sights and places—nature, people, colors. A photograph, taken by my son in his travels, captured a different way of life in a foreign land. I was inspired by the multicolored fabrics stacked in layers on the woman's head and used many of the hues in the bundle to highlight the woman's skin tones.

D. J. MURRAY
Haitian Lady with Fabric
22 x 17 in. (54x44 cm)
Surface Used: Windberg Pastel, Dove Gray

Murray uses a large palette in this stylized illustration. To lift or remove color from the traditional layering technique, she uses Frisk film or a white plastic eraser.

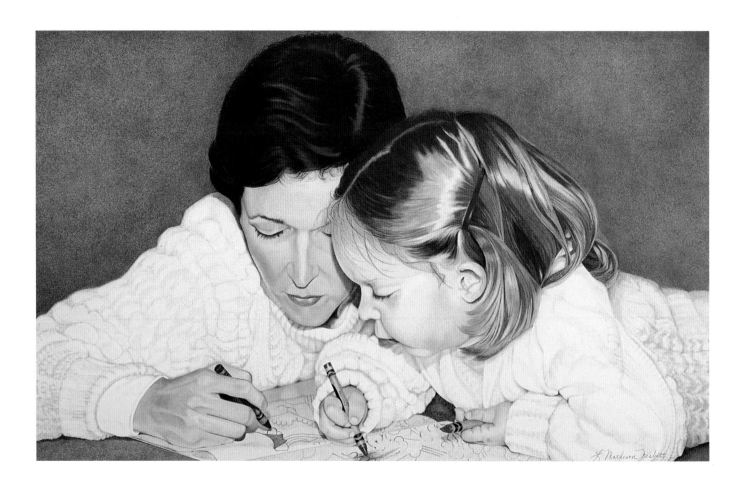

LORRIE MATHESON NESBITT
The Drawing Lesson
15 x 24 in. (38x60 cm)
Surface Used: Crescent 100% Rag Cold Press
 Illustration Board, White

To give the background a grainy texture that
would appear solid but not overpower the soft
sweaters, Nesbitt uses solvent on cotton balls to
blend the pigments. The focal areas of the faces
and hands were defined by sharper edges, heav-
ier layering and some burnishing.

Many times words become a barrier to communication. People often do not listen for lack of interest in
you or what you have to say. However, when I paint, even though not everyone will listen, what I have
to say is out there, left for the viewer. Art gives me the opportunity to speak, and I need not be present
to communicate. There is that magical moment when I see that I have made a connection with the view-
ers. I have touched them. It is in this process of communication that our differences are overshadowed
by the light of our similarities.

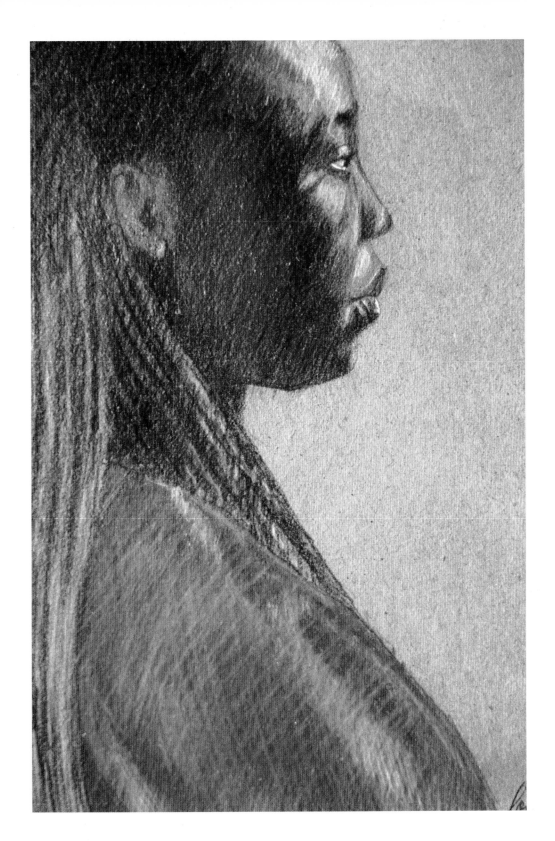

Before this particular piece, I met Lô, the model, in the Montreal Metro. She has a marvelous face and expression. I asked her to pose for the life drawing group I meet with on Thursdays. When she came to the studio for the portrait, her attitude, black and bronze colors, and violet dress were all perfect to create a strong presence. Colored pencil is the medium of simplicity, the minimum of material, the right medium for a minimalist approach.

LOUISA NICOL
Lô
40 x 30 in. (76x102 cm)
Surface Used: Kraft Recycled Acid-Free Paper
 Roll, Gray

"Lô" is completed freehand in a single session. Nicol uses the gray color of the paper as her mid-tone. She prefers to draw subjects actual size whenever possible.

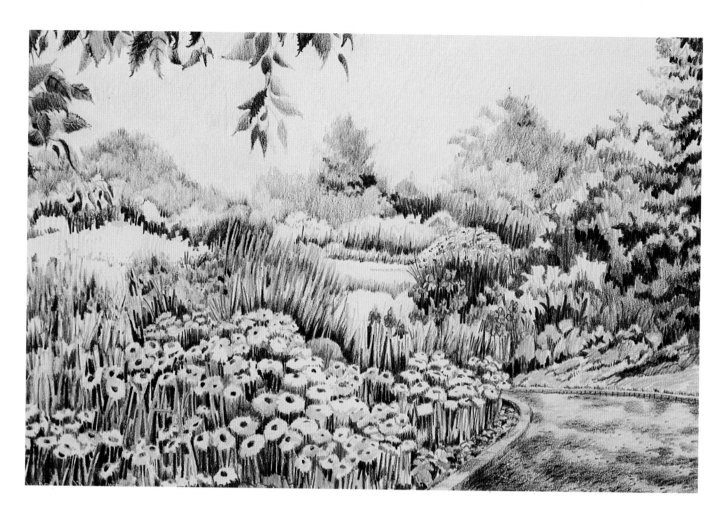

MARY ELLEN NIX
Summerday
18 x 24 in. (46x61 cm)
Surface Used: Rising 4-Ply Acid-Free Museum
 Board, White

Rather than working one area at a time, Nix immediately sets down masses of light values over the paper. She works quickly with a handful of pencils and randomly adds colors. This work was done with vertical strokes and impressed lines.

Near my home is the Chicago Botanical Garden, a beautiful place with ponds, woods, prairie, and a huge array of plants in a variety of settings. On walks through the Garden, I was attracted by the riot of colors and textures, and by the way the path drew me into the scene. While I took many snapshots, I first worked on location to produce watercolor sketches and paintings. Months later, my photos reminded me of how appealing the scene was. The colors, shapes, and textures were what I wanted to capture in colored pencil. Showing the play of light over the garden took precedence over capturing a realistic rendering.

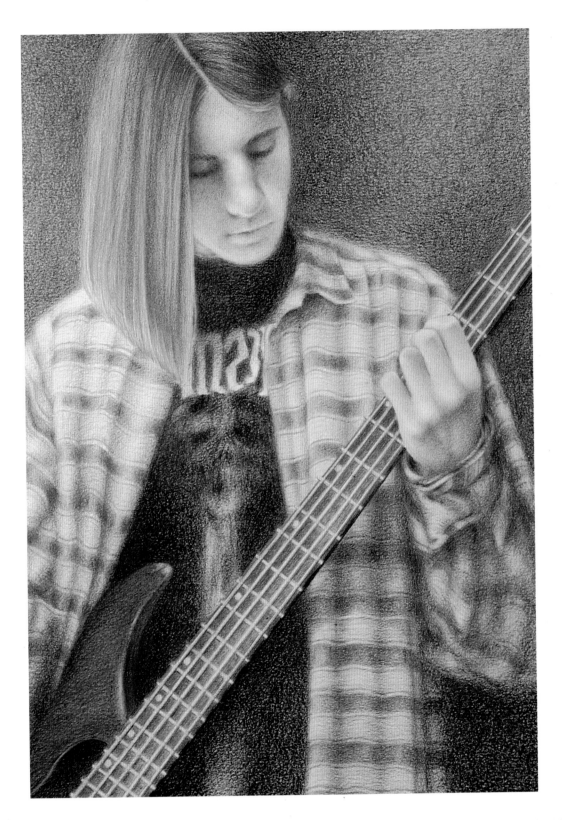

The human face has always fascinated me—how every single one is so wonderfully unique. The challenge of capturing not only its physical complexities but a reflection of the inner person has sustained my love of portraiture through the years. *The Bassist* captures my son, Chad, in a pose that reflects both his passion for music and his often somber personality. Looking through the photos I had taken, another side of Chad began to emerge. The almost tender way he held his guitar and the peaceful quality of his expression convinced me to include the loving, gentle side of Chad that is also an integral part of his character.

KATHI GREEN NIXON
The Bassist
16 x 11 in. (41x28 cm)
Surface Used: Strathmore Bristol 100 lb. Acid-
 Free Board, White

Nixon chooses the colors she will use before beginning. To maintain the soft, hazy look, she avoids hard or crisp edges, allowing one area to flow into the next. She completed this work in forty hours.

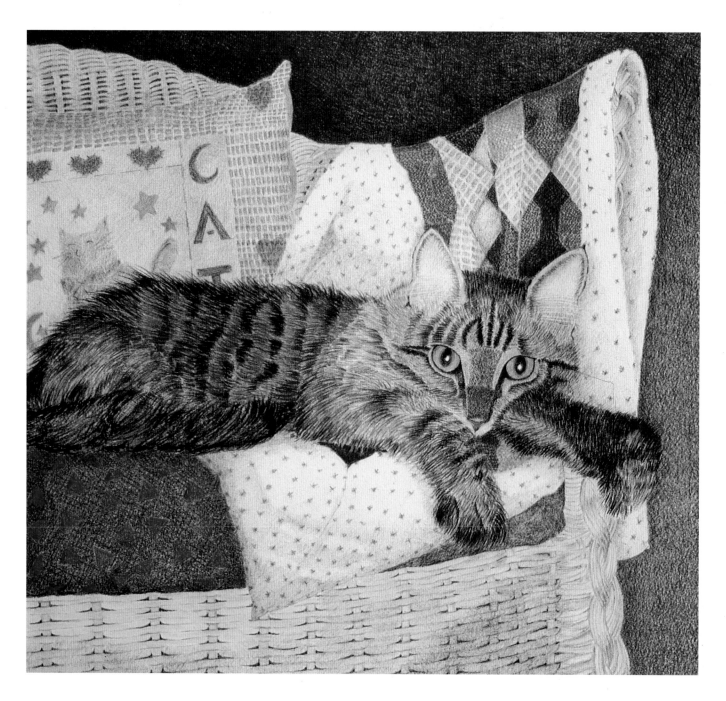

SUSAN K. NOON
Stella
13 x 14 in. (38x36 cm)
Surface Used: Rives BFK Acid-Free Paper, White

Noon applies various shades of gray, blue, brown, orange, and purple to the cat fur. The background's original crosshatch texture competed with the other patterns and was subdued with a kneaded eraser.

My reference source was several bad photographs which were underexposed, red-eyed, and with almost no discernible details. I worked directly with the cat to get the color of her incredible green eyes and texture of her fur. The variety of patterns in the cushion, quilt, wicker, and cat make the composition interesting.

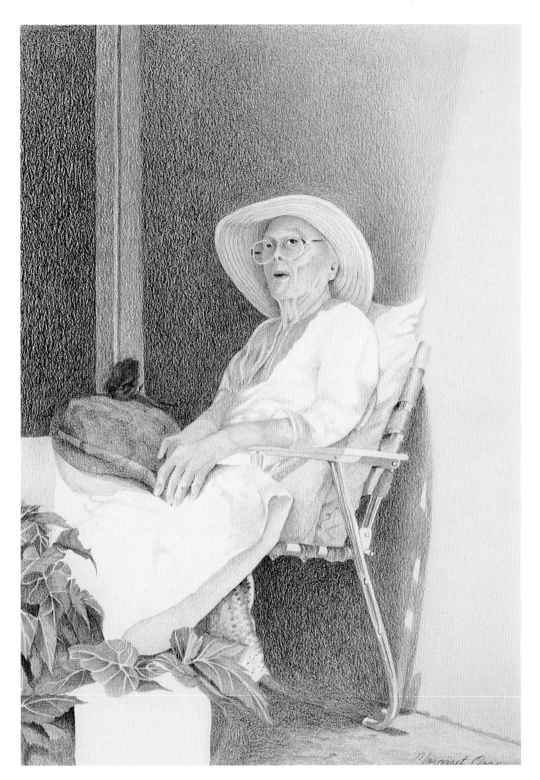

Last Day is a portrait of my grandmother, Ethel McClaflin, who died at the age of 86. An astoundingly strong-willed, independent woman, she lived her life on her own terms and faced her death the same way. I was in awe of her incredible dignity as she increasingly became at the mercy of those of us who took care of her. It was this strength and dignity that I hoped people would see in this old face, with the clear blue eyes facing directly out toward the light. I think Grandma would like this rendition, but she would say she looks too old—and she never was too fond of that hat.

MARGARET J. OGAN
Last Day
18 x 24 in. (46x59 cm)
Surface Used: Rising 2-Ply Regular Bristol,
 White

Ogan gives a poignant message, and creates a strong focal point, by placing the subject between the darkness and light. She keeps the intensity of the colors light to maintain a feeling of fragility. The background was scumbled with a stump, which lightens and blends the colors.

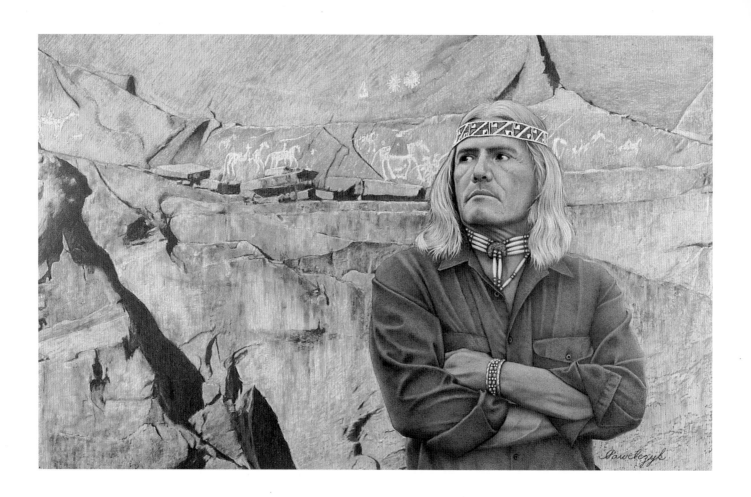

STANLEY PAWELCZYK
In Touch With His Ancestors
25 x 31 in. (62x79 cm)
Surface Used: Clear Mylar .004 Gauge

Pawelczyk paints his photo-realistic style on clear Mylar and sprays a satin fixative as a finish. Using a combination of reds and browns, he creates most of the rock formations using a vertical stroke and very sharp pencils.

Some of my favorite memories are of my numerous vacations to the western portions of our country. Besides enjoying the time to get away, I am able to research and photograph subjects for portraits. I've been to many "pow-wows" from coast to coast and met the gentleman in this piece. You can see from his dress that he is from the present time, so I decided to place him with a background from the past. In painting native Americans and cowboys, I especially like capturing all the little details, such as the folds in clothing—making the various textures look real. Not just realistic, but real enough to jump out of the picture at you.

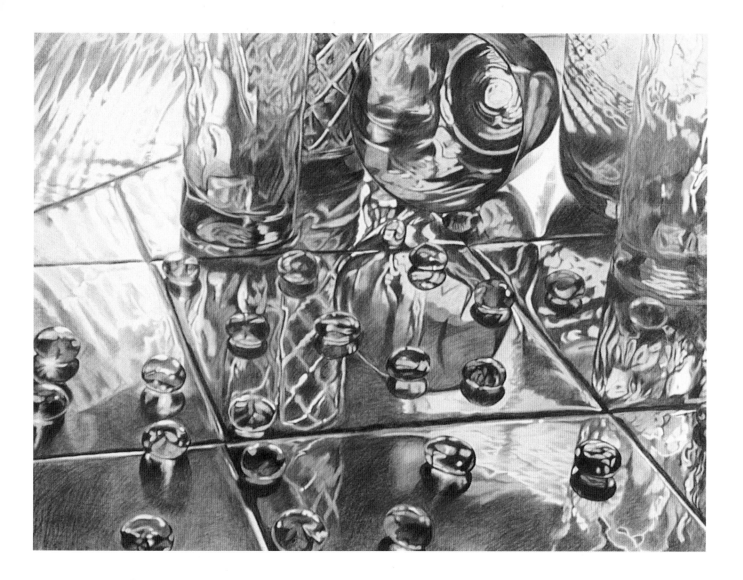

As an artist, I have an affinity for representational imagery. However, years of study and work in design have definitely influenced my work. While the end result may be realistic images, the conceptual process is occupied with more formalist concerns of visual structure: design, shape, pattern, value, and color. My recent work consists of still life constructions built around my interest in light, color, and reflective surfaces. Light and color appeal to me for their dramatic and psychological potential. Metal, glass, and other surfaces are used to exploit these qualities. I am intrigued in the way reflected shapes are distorted, leading to wonderful abstract passages.

CYNTHIA PETERSON
Blue on Blue
22 x 30 in. (56x76 cm)
Surface Used: Lanaquarelle 140 lb. Hot Press
 Paper, White

"Blue on Blue" is one of a series based on exploring color relationships. Peterson works from objects in a limited color range using only transparent objects. She blocks the image of her composition by projecting the negative of the photo.

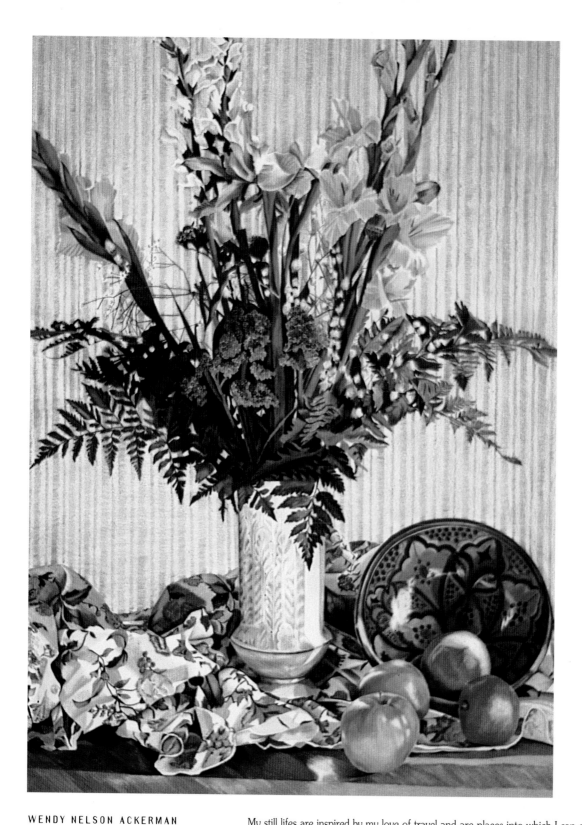

WENDY NELSON ACKERMAN
February's Bouquet, My Valentine
36 x 28 in. (91x71 cm)
Surface Used: Fabriano Murillo 360 Printing
 Paper

Ackerman sets up a still life and then works
from photographs she has taken. She burnishes
the wallpaper to create a muted backdrop for
the subject. The focal point is a balance of light
and dark areas. She uses an eraser to smooth
colors and soften hard edges.

My still lifes are inspired by my love of travel and are places into which I can escape. As a child I was
influenced by the colors, patterns, and designs of Greece; the fabrics of Turkey and Romania; and the
sights and sounds of France. These memories remain a part of me. I search for patterns and details
because I find them comforting visually and emotionally. The vases, fabrics, flowers, and other objects in
my studio are a constant reminder of places yet to be discovered. It is a constant joy to approach each
new still life and travel through its composition.

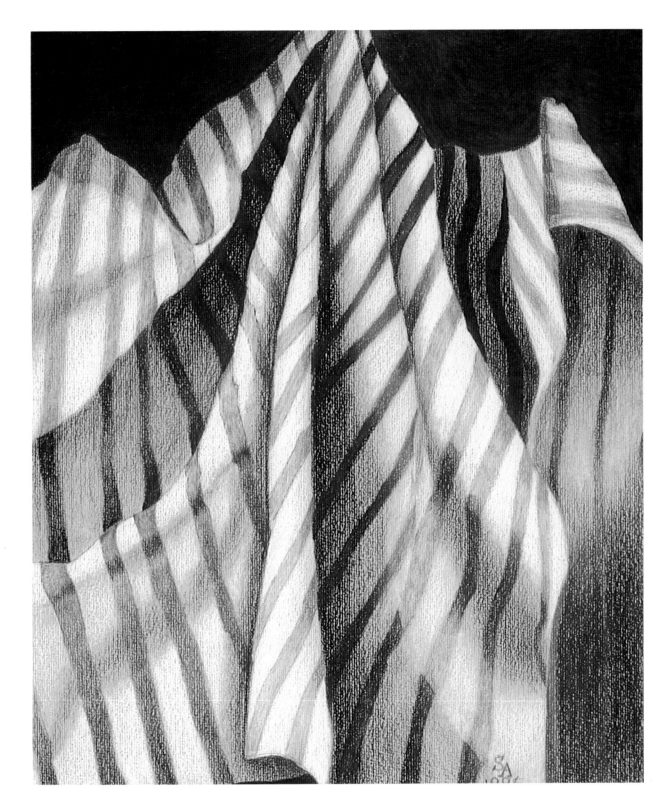

One of the most important lessons I have learned is to enjoy the process of art rather than to focus on the "product." Releasing myself from the burden of having to produce a beautiful work of art has allowed me to express myself more fully. *Striped Fabric* was essentially a building block in my personal learning process rather than art designed to make any specific statement. The motivation was born out of a desire to learn more about light and how to express motion and changes in fabric.

STEPHANIE ALBANESE
Striped Fabric
14 x 11 in. (36x28 cm)
Surface Used: Canson Mi-Tientes, Dark Blue

Working with a dark-colored surface, Albanese applies a limited palette of white, blue, and purple in several layers. Fabric areas in the brightest light are burnished smooth, while texture is allowed to show in the darker shadows.

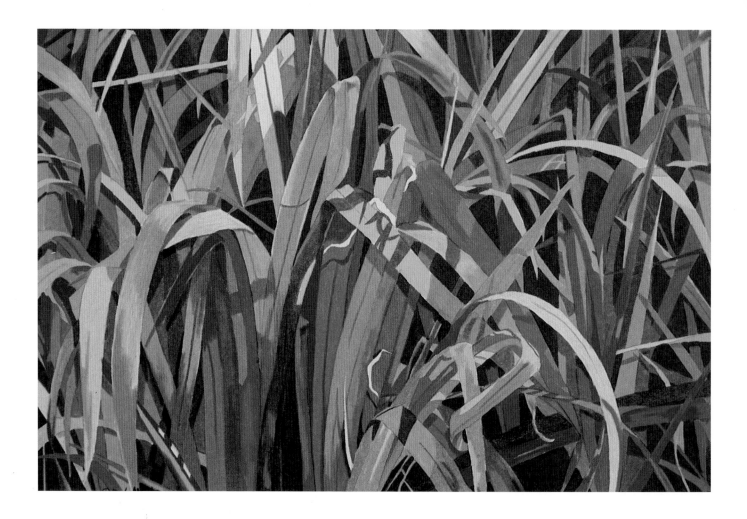

DARRYL d. ALELLO, CPSA
Irismetrics
7 x 10 in. (18x25 cm)
Surface Used: Strathmore 400 Medium 4-Ply,
 White

To define the positive shapes of the subject and
push them forward, Alello begins by applying
Indigo blue, Tuscan red, violet, and dark purple
in the negative shapes of his contour drawing.
Balancing the many hues of his palette can
make color choices tricky. He simplifies the
selection process by physically placing the pen-
cils in the uncompleted areas of the work.

Because floral paintings have been done for hundreds of years, I am inspired to paint something differ-
ent and equally as beautiful—the leaves. By looking deep into foliage, blocking out everything else, I see
a multitude of light and dark patterns. These intertwining values define the positive and negative shapes
that make up this painting. I broke down the complex foliage in *Irismetrics* into simple abstract forms,
and used a broad range of colors to replace a mundane field of green. While my realistic approach
allows the viewer to recognize ordinary subjects, I lend a freshness to them through the unique use of
color and design.

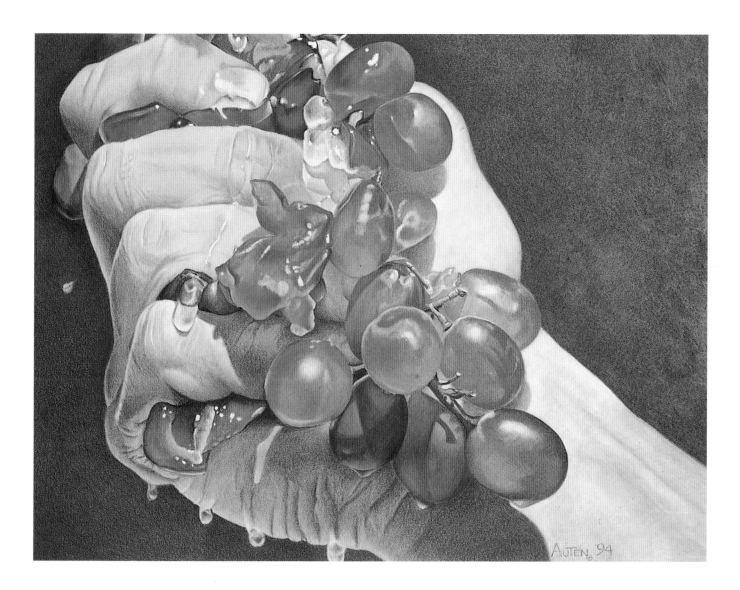

Being considered color recessive means that I see colors, but not all their gradations. Therefore, the colors in my work are usually subdued, while the subject matter is bold. Since color is not the primary aspect of my artistic vision, value, form, and composition become the dominant elements. I work only on a colored surface because most hues look too bright or garish on white paper. I first establish my values with black and white pencils, using the colored paper as the middle tone, and keep my palette somewhat limited throughout the work. What others may view as a handicap, I believe is what makes my art stand out.

BONNIE AUTEN, CPSA
New Wine
19 x 25 in. (48x63 cm)
Surface Used: Crescent 100% Rag 4-Ply Mat
 Board, Rough

After the foundation colors are laid, Auten uses a colorless blender to remove the graininess of the paper. The blender allows her to move the dry pigment around in a painterly fashion while filling the surface texture. Other colors, layered over those blended, become more intensified.

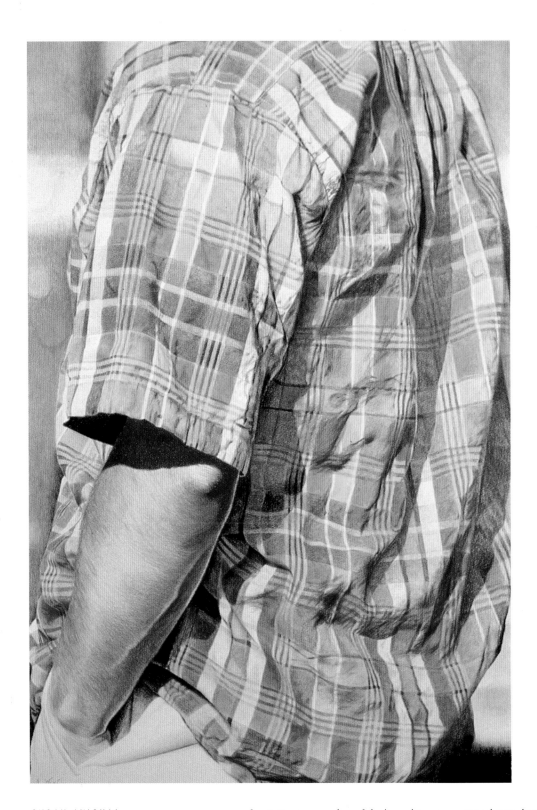

SUSAN AVISHAI
Madras
28 x 19 in. (71x48 cm)
Surface Used: Rives BFK 100% Rag Paper, Gray

Mixing colors as the stripes travel up and down folds, interweave, or disappear in shadows is a challenge. Avishai uses an opaque projector to cast the basic placement of the image onto the surface. She applies warm colors with a tonal application throughout the painting. Notice the textural variations between the skin and fabric.

Inspiration is everywhere. I don't need to preconceive what to draw—its all around me if I'm alert. I often find myself drifting away from conversations to study the folds of fabric around an armpit or elbow. The image for *Madras* came from a clothing catalog. I cropped as much as possible without losing the essence of the gesture or the character of this man. With his back-to-the-viewer nonchalance, his powerful, masculine forearm, and his preppy choice of shirt and white pants, do we really need his head to know just who he is?

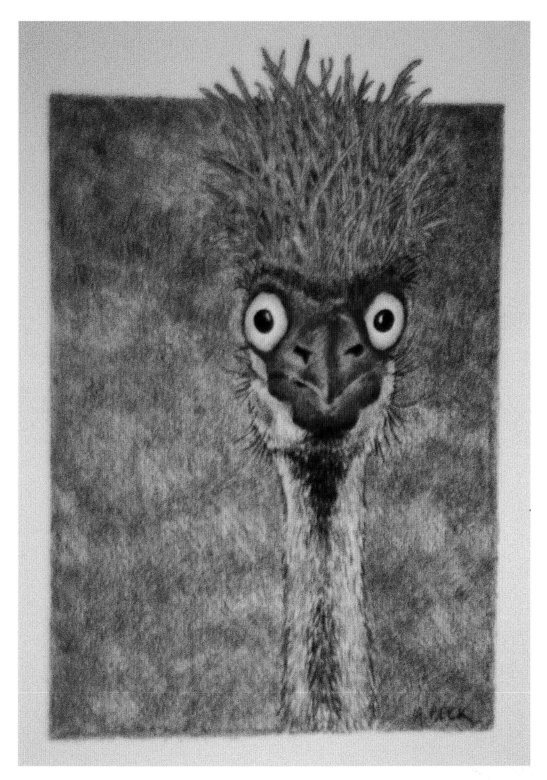

Art is very relaxing. It's the type of activity where time passes effortlessly; and if you get past being your worst critic, there are lots of rewards. *It's Morning* originated after looking at some baby birds. I was reminded of a friend who always woke up with a bad-hair day. To emphasize the bird's expression (a little stressed and out of control), I kept the picture simple, and muted the background colors and shapes. It's amazing how many people seem to relate to this illustration by exclaiming, "That's me!"

ALISON BECK
It's Morning
8 x 6 in. (20x15 cm)
Surface Used: 4-Ply Museum Board, White

The frazzled appearance of this amusing illustration is projected through Beck's use of short, lively strokes and contrasting color temperatures. She applies three-to-five color layers to various areas and blends them with a white pencil and heavy pressure. Her color decisions are made spontaneously as the work evolves.

JEFFREY ANN SMART BAISDEN,
CPSA
SAN DIEGO DC 202 AWARD
The Colonel
31 x 18 in. (79x46 cm)
Surface used: Strathmore 4-Ply Museum Board,
White

"The Colonel" is a composite made from several photographs. Baisden uses patterns and red hues in the background clothing to add interest to the subject. Her converging perspective of the closet doors and rack emphasizes the importance of the implied figure.

Insights are revealed through the posses-sions we accumulate and how we arrange them. For me, closets present a constantly evolving portrait of the owner. *The Colonel* is a peek into my husband's pri-vate space—a symbolic portraiture. I chose a military presence in creating a narrative of his character and personality. The center of interest is a royal-blue robe hanging "at attention." To emphasize the implied figure, I placed his military-dress hat strategically on the rack above the robe. My goal in the closet series is to draw viewers into spaces we take for granted and allow them to respond to the contents.

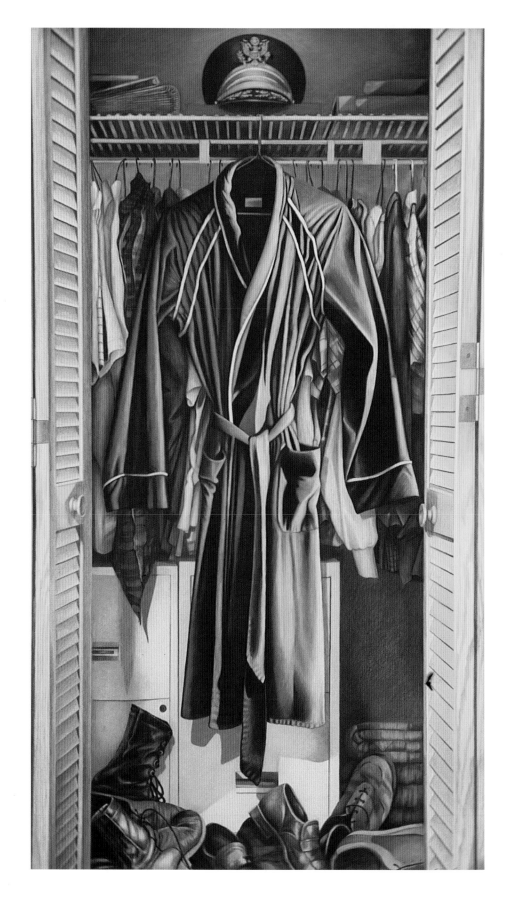

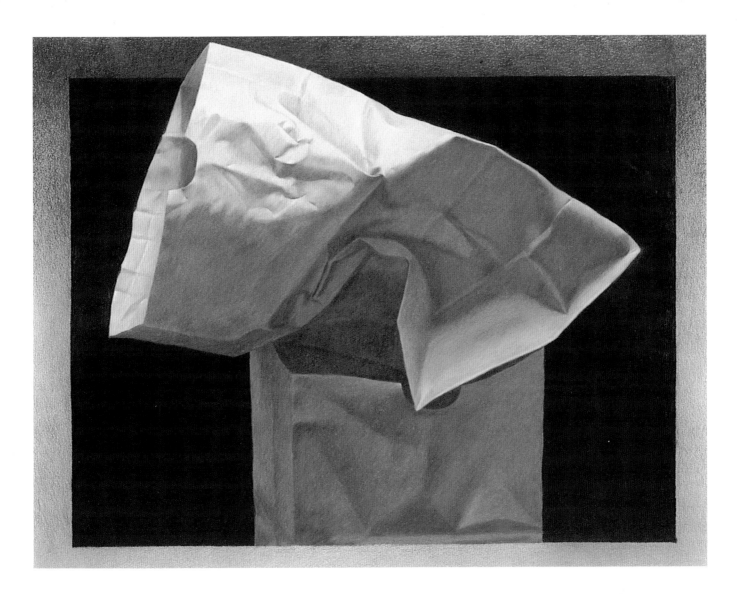

This painting is one in a continuing body of work which I began about six years ago. I wanted each piece to be unique within itself, but at the same time be consistent within the group. To do this, I followed the same sequence of exacting procedures. These included using the same setup, source of artificial light, distance of observation (one arm's length), paper type and size, dimensional layout, palette, and method of application. I intend no "message" other than to show how a throwaway object can be turned into a meaningful and expressive subject.

JOE BASCOM, CPSA
BRUYNZEEL FULL COLOR AWARD FOR
 OUTSTANDING RECOGNITION
Brown Paper Bag No 102
23 x 29 in. (58x74 cm)
Surface Used: Strathmore Acid-Free 3-Ply Kid
 Surface, White

Because the concept for each painting is complete from the beginning, Bascom does not make any changes or erasures during the process. He layers the paintings tonally with the same sequence of five colors: yellow ochre, light umber, sepia, black, and white.

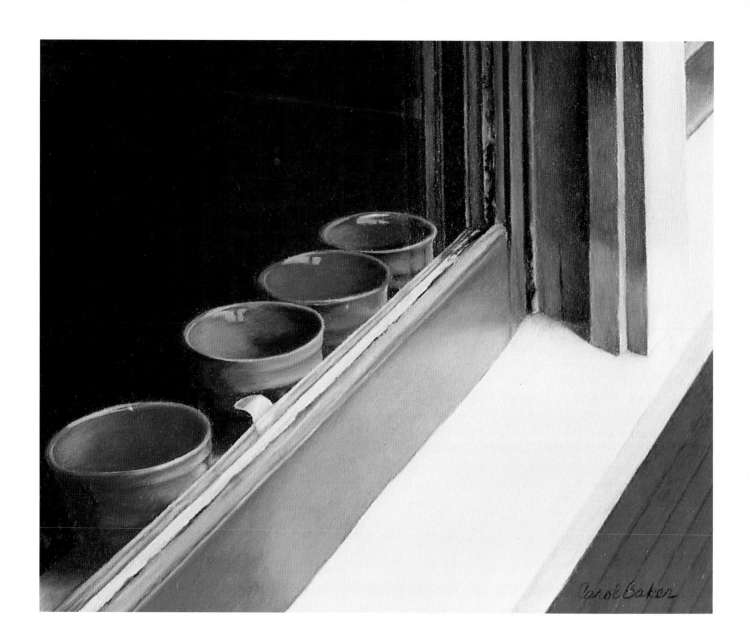

CAROL BAKER
GALLERY ALLIANCE AWARD
Kitchen Window
12 x 14 in. (31x36 cm)
Surface Used: Rives BFK 250 Acid-Free
 Printmaking Paper, White

Using a very sharp 90% French gray, Baker
makes small circles with the slightest amount
of pressure to evenly distribute the pigment in a
tonal application. Once this 'grisaille' is accu-
rately developed with layers of gray, she intro-
duces the local colors by slowly increasing pres-
sure to finally obtain the glassy appearance of
the jars.

This still life attracted me because of all the sharp contrasts it contains. For instance, the vivid colors of the
jars confront the soft cream of the sill and blue of the window frame. The counteraction of clear architec-
tural lines of the window juxtapose the roundness of the jars. Diagonal lines intersect vertical lines in the
window structure. The clean smoothness of the jars and freshly painted wood opposes the deteriorating
wood and paint inside the window frame. And the contrasting values from the dark, unknown room inter-
play with the bright, sunlit window sill. This visual dissension engaged my curiosity about the subject.

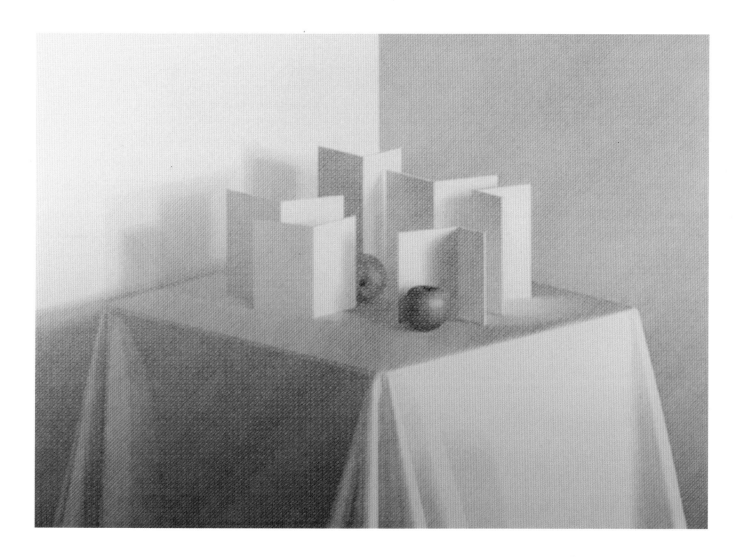

A distinctive feature of my large-scale colored pencil drawings is the use of a *hachure* (or hatching) technique traditionally reserved for works in black and white. This technique models form through the use of parallel lines. By adding linear layers of contrasting colors, I am able to produce what appears to be a full range of color. To ensure the controlled, print-like effect I seek, I draw each line with a straight edge. For me the still life is like a miniature stage on which the objects are the players—meaningless in isolation, they become relevant in relationship to each other.

WILLIAM A. BERRY
THE ARTIST'S MAGAZINE AWARD
Still Life: Apple v. Orange:
 Arles
30 x 40 in. (76x102 cm)
Surface Used: 2-Ply 100% Rag Museum Board,
 White

By altering the color emphasis, Berry creates a wide range of color modulation with four hues: sanguine, light blue, ochre, and light gray. He crosshatches the lines so colors are never completely blended. Pure color remains visible even in the darkest passages. The whitest areas are left untouched.

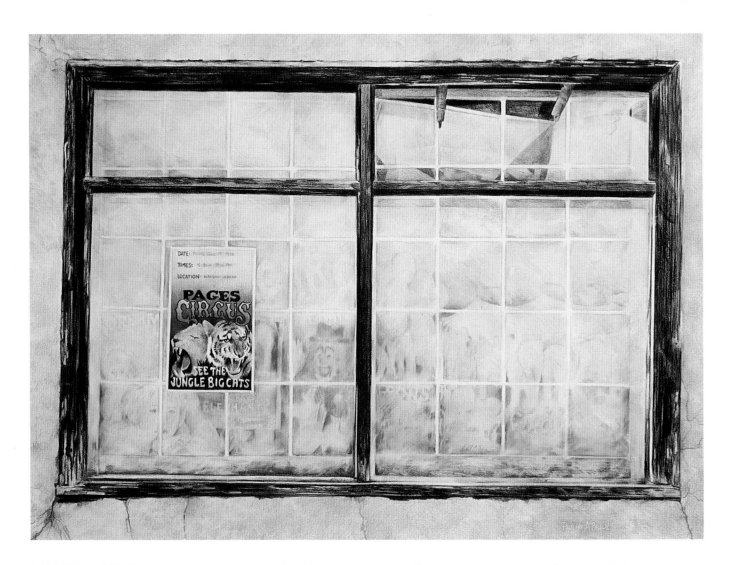

PAULINE A. BRAUN
CANSON-TALENS AWARD
Window of Dreams
19 x 28 in. (48x71 cm)
Surface Used: Rives BFK 100% Cotton
 Printmaking Paper, White

Braun's watercolor-glazing technique influences
how she builds colors that glow with colored
pencil layers. She alternates layers of comple-
mentary colors, varying the shades for variety.
Because erasers damage the soft paper sur-
face, she uses masking tape to lift color.

In *Window of Dreams,* I was attracted by the contradictory emotions this scene evoked.
The brightly colored poster contrasts the faded and dilapidated building. The excitement and
anticipation that the circus brings is replaced by a feeling of emptiness when it leaves. It is this
mood, this emotional roller coaster of feelings that I wanted to convey. I have done several pieces
centered around windows. Capturing the glass surface and the images it reflects on several
different planes is an enjoyable challenge.

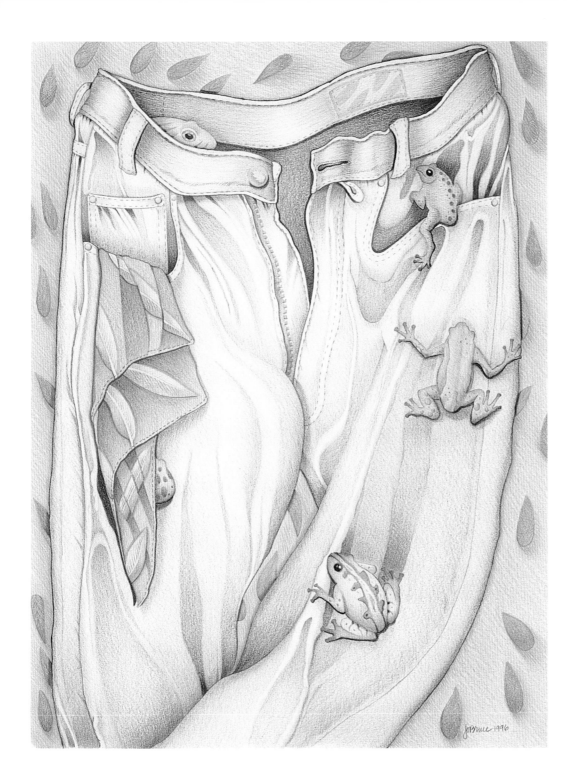

In my art, I attempt to express humor in the mundane by contrasting everyday objects with slightly askew elements. These are not sophisticated proclamations, but gently light-hearted observations. The idea for *Frog Legs* came from an intaglio etching I did many years ago. I decided to recycle it, with embellishments, using colored pencils. As my original sketch becomes a memory, my drawing takes on a life of its own. This departure from the draft is the most precious part of the process—it's when the intellect, emotion, and subconscious merge to create art.

JUDITH ORNER BRUCE
Frog Legs
21 x 16 in. (53x40 cm)
Surface Used: Rising Stonehenge Acid-Free
 Printmaking Paper, White

Bruce uses a complementary and split complementary color scheme. She creates movement within the composition through color and design. Notice how the frogs mimic the patterns in the wallpaper and scarf and add interest to the mass of blue.

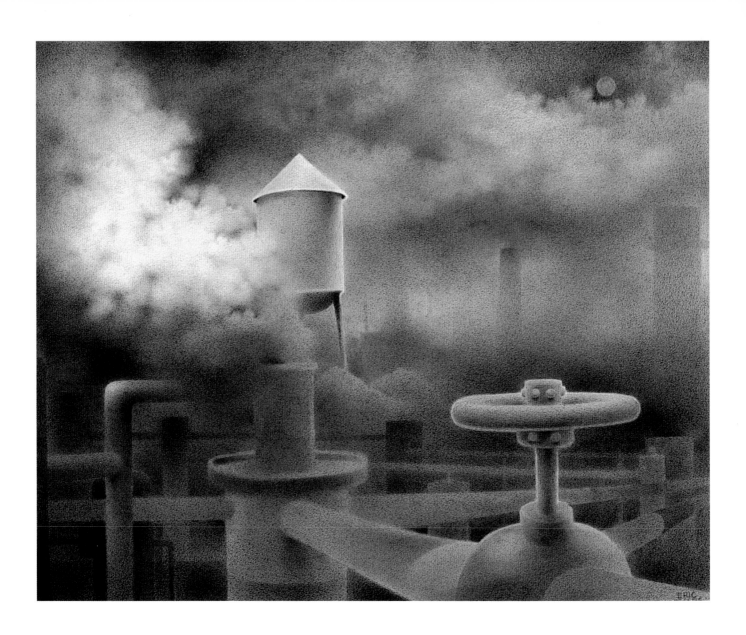

ERIC BYARS, CPSA
DERWENT FINE ART PENCILS AWARD OF
EXCELLENCE
The Complex
16 x 20 in. (39x48 cm)
Surface Used: Bainbridge Cold Press 1-Ply
Illustration Board, White

Byars never works from photographs. For him,
genuine inspiration comes uninvited. While Byars
spends a lot of time looking at photographs, it's
only the memory of their effects that he uses. His
velvet-like tonal application took him over 400
hours to complete this painting.

I don't usually do industrial subjects. During one family outing, however, I did three drawings which included a jetty, water tower, and smokestacks. *The Complex* is based on these pencil sketches done twenty years ago. When I happened across them last year, I instantly saw how they could be combined into one composition. Besides the subject, the reference materials were also a departure for me since I don't usually base work on sketches I do on location. But the visual effects of smoke always fascinate me. The drawings provided a feeling of melancholy and the dramatic touch I wanted for a colored pencil painting.

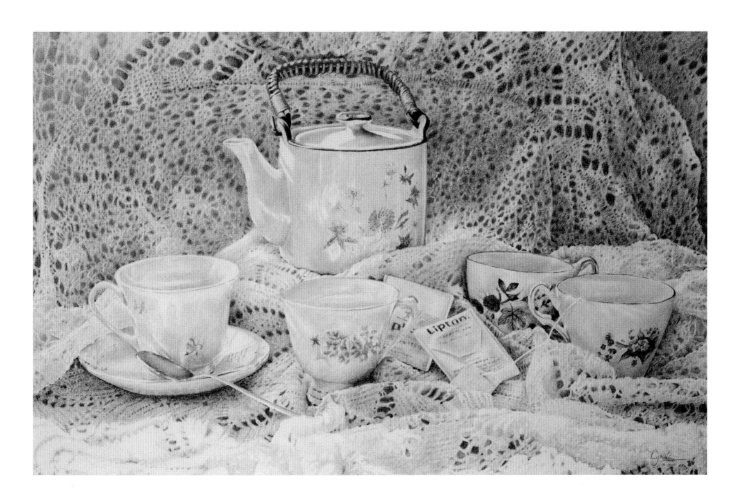

In the middle of the winter season in Pennsylvania, it is not unusual to hear the radio announcer say, "Due to heavy snowfall, the following school districts are now closed...." This is how *Suzanne's Treasures* was born—a day off from teaching school and nowhere to go. The subject of this painting, rife with personal meaning, inspired me. As an artist, the challenges kept me motivated—from the subtle color reflections in the porcelain cups and texture of the lace to the white-on-white composition. I worked methodically and completed a section at a time to achieve this photo-realistic image.

LYNN A. BYREM
FRIENDS OF CPSA AWARD
Suzanne's Treasures
19 x 25 in. (48x64 cm)
Surface Used: Bienfang Art-Vel 211, White

Starting with light colors, Byrem gradually adds the darker values. To make the tea set stand out from the white tablecloth, she infuses more dramatic shades of color into the shadows. Byrem burnishes frequently in between the eight or more layers of color.

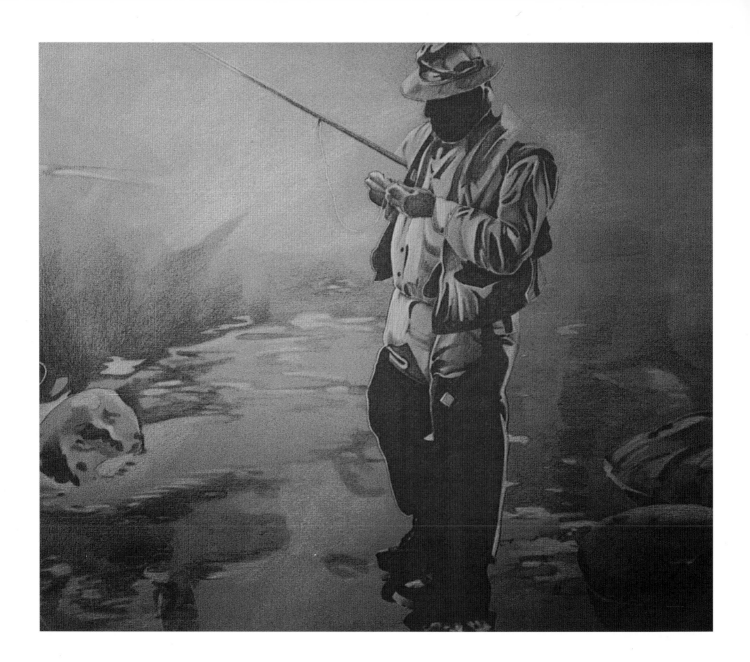

CHRISTOPHER CAMPBELL
To Get Away
17 x 20 in. (43x51 cm)
Surface Used: Strathmore 100% Cotton
 Charcoal Paper, Orange

In this painting, Campbell only uses violet blue
and canary yellow pencils, allowing the orange
surface of the paper to act as a third color. He
deliberately avoids blending the two colors and
leaves them pure on the paper. By simplifying
details, he completed this piece in a half-hour.

I am affected more by color when it is used in an abnormal context. The people I draw inspire my choice of colors. I enhance how they must feel with colors that coincide with their emotions. In *To Get Away* the lack of detail in the man's face allows us to imagine his expression. And color helps to interpret his emotions. By merely suggesting a background and eliminating his face, I have detracted the focus from what is happening behind him, or even with him. The viewer is left to experience the simplicity in art and the freedom of emotions in life.

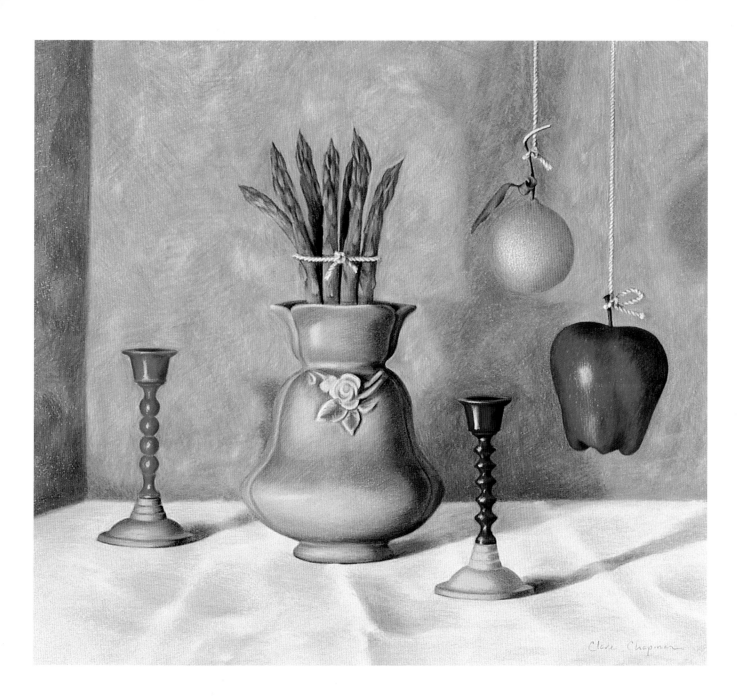

Sometimes I plan a work carefully; mapping out the precise position of each element, the source of light, and the location of cast shadows. *Eclipse* began with the central vase, but I had no idea what objects would surround it. As this drawing evolved, I added and worked in objects in a clockwise direction, intuitively balancing color and shapes. I chose a lighter background because, for me, the shadow cast—or not cast—by each object is an important element of the composition. My aim was to simply capture a moment with everyday objects grouped in an unexpected and pleasing way.

CLARE CHAPMAN
Eclipse
17 x 19 in. (43x48 cm)
Surface Used: Strathmore Bristol 500 3-Ply
 Medium, White

A key to burnishing is knowing when to begin the process of pressing harder. On this piece, Chapman realized that she had built too much dark color on the shadow side of the apple and burnished it too soon. She corrected this problem by using a razor blade to first scrape off some color and then to recreate the tooth of the paper.

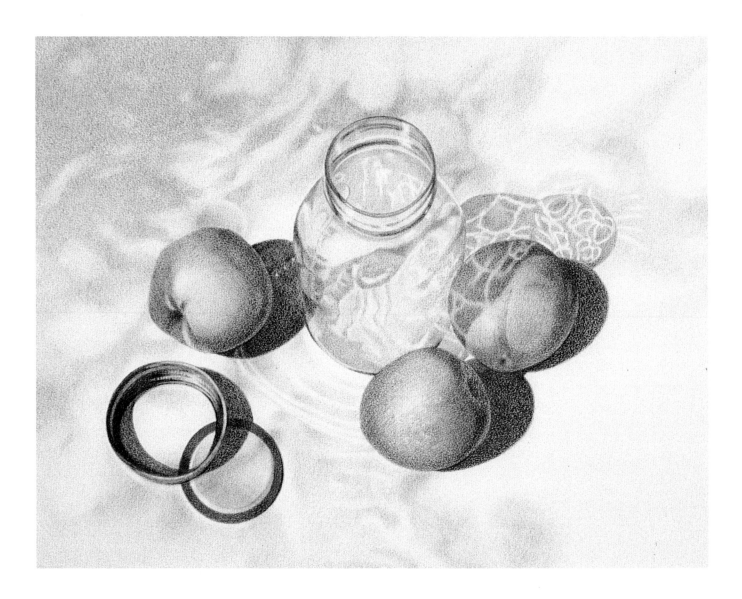

KATHRYN CONWELL
Canning Jar with Peaches
12 x 16 in. (31x41 cm)
Surface Used: Strathmore Acid-Free 3-Ply
 Museum Board, White

To accurately draw the turning contour of the
screw-top lid, Conwell traced the actual lid onto
tracing paper and then aligned it over the photo.
This allowed her to see where and how the per-
spective changed. She could then apply the
same procedure to the drawing surface.

Rather than arrange this still life indoors with a spot light, I decided to take advantage of the filtered sun-
light coming through the leaves of our large pecan tree over the cement driveway. The reflections of the
glass jar and the subtle hues of the blue and aqua glass were intriguing against the simple background. I
prefer this overhead perspective on an object instead of that seen at eye level. Although I have worked
in watercolors, oils, and pastels, I found my forte in colored pencils. Besides the control and detail of this
medium, working over the paper in rhythmic strokes is very therapeutic and meditative.

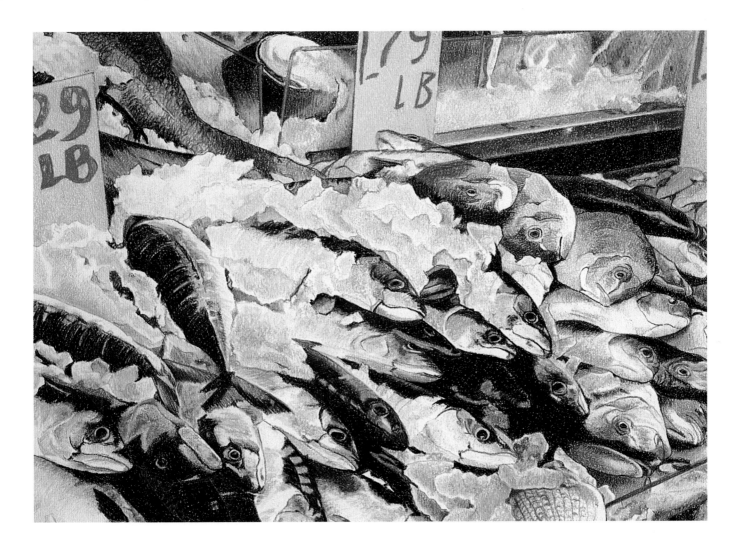

You can't fall in love with your reference photograph; you must be able to edit the image so it tells the story you want to portray. Cropping is really crucial to the whole process. The photo of the fish market was cropped tightly, leaving just enough bits and pieces of surrounding elements to frame the subject. The fish and glass bins set up opposing diagonals to form a good composition, and the black fish against the ice provided a good contrast of light and dark elements. I balanced the spatial relationships of the bright yellow signs for contrast and eliminated objects that would detract from the subject.

CIRA COSENTINO
Fish Market
16 x 18 in. (41x46 cm)
Surface Used: Canson Paper, Ivory

As an illustrator, Cosentino sometimes has the need to recreate a drawing or to be able to reuse portions of it. She enlarges the reference photo to an 11"x14" print and traces its image with pen and ink onto a sheet of Mylar. After she transfers the outline drawing to paper, she keeps it on file for future reference.

ANNA P. COUCH
My Cat
11 x 9 in. (27x22 cm)
Surface Used: Color-Aid, Black

Since Color-Aid paper is unforgiving and does
not tolerate corrections well, Couch plans her
composition in advance and works gently in a
small, circular motion. This permits her from fill-
ing the grain too quickly and allows her to build
reflective fragments which give the illustration a
glow.

I am passionate about illustration. It demands large amounts of thoughtful energy so that it can commu-
nicate effectively. It is the evolution of an idea that can be read without words. *My Cat* is my graphic
interpretation of a published book about children and their giant-size pets. I felt the original illustration
created a threatening visual message for young readers. The challenge was to see what I could do visually
to create a comforting image. I substituted the brown and orange with a warmer palette and used curves
to soften the atmosphere.

I'm obsessed with reflections. With the slightest movement, a new color develops to change the mood, or another distorted pattern appears. Like a chameleon changing with the environment, my subjects reflect the minute fluctuations of their surroundings. In those split-second moments, inspiration is reflected back to me. I am compelled to make it mine on paper. In an attempt to savor the moment, it seems oddly appropriate to choose a labor-intensive medium such as colored pencil to portray a "flash in time."

DEBORAH CURRIER
Catch of the Day
16 x 21 (41x52 cm)
Surface Used: Arches 140 lb. 100% Rag Hot
 Press, White

The artist used art sticks to fill in the large areas and colored pencils for smaller spaces. Currier blends the wax layers with tissue and cotton swabs, applies a heavy layer of white pencil, and then intensifies some colors with a final layer. She creates texture in the foreground with pigment and solvent. This illustration was completed in sixteen hours.

LUANNE D'AMICO

Lustreware III

12 x 17 in. (31x42 cm)

Surface Used: Bainbridge Bristol Vellum, White

To avoid smudging, D'Amico works down from the top left corner, completing each area as she moves across the paper. She applies color from dark to light in half-inch strokes, adding hard lead graphite pencil between layers. This adds depth by blending the colors into smooth layers.

Inexpensive china produced in the 1920s in Japan, Czechoslovakia, and other countries fascinates me. Its sometimes poor quality adds to its charm with colors changing according to the objects and ambient light surrounding it. *Lustreware III* has personal meaning in that the objects belong to my mother and grandmother. As with most of my work, I like to "zoom in" and let the subject fill the entire area. In working this way, each shape and line is critical to the overall design and the negative areas become as important as the positive.

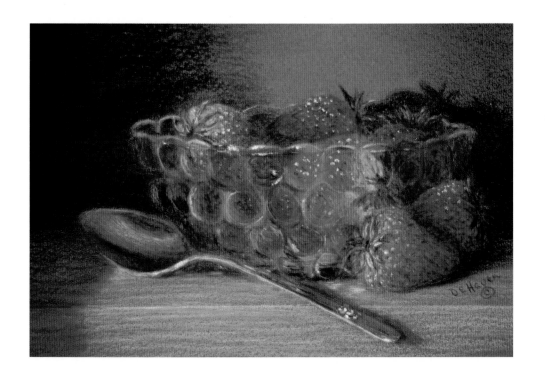

MARTHA DEHAVEN
SANFORD DESIGN SPECTRACOLOR
AWARD OF EXCELLENCE
Bowl of Berries
10 x 12 in. (25x30 cm)
Surface Used: Canson Mi-Tientes, Dark Gray

DeHaven employs the technique called chiaroscuro to balance strong lights and darks and create pronounced contrasts. The dramatic beam of light provides relief to this dark, low-key painting and allows the subject to emerge from the shadows.

When doing a period piece, I research its history and in doing so expand my connection not only to the object but to its previous owner. I found the knobby glass bowl in an antique shop and knew that the light distortions it could make would present an interesting challenge. My intention for *Bowl of Berries* was to create a quiet, introspective little piece that expresses an old-world feeling. By using a dramatic side light in this still life arrangement, I am able to combine the old masters' style of chiaroscuro with the modern materials of today's colored pencils.

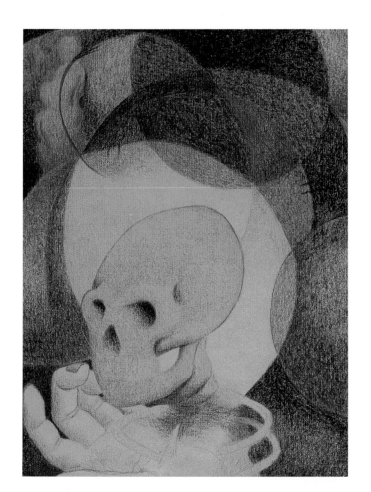

SHARI KIRK
Expect Nothing
16 x13 in. (41x33 cm)
Surface Used: Strathmore 400, Acid Free Paper, White

Kirk selected a triadic color harmony of orange, green, and violet before determinig what the subject would be—*Expect Nothing* evolved as the work progressed on her drawing surface.

Many viewers will find my images a little unsettling. For me, art is extremely cathartic—each piece a result of some personal mood or experience. At one time, I wanted to explain my work to everyone so they would know how to view it. Now, I feel this infects their perceptions until their unique interpretation is lost forever. I want people to take the symbolic language and icons I incorporate into the illustration and affix them to any individual importance. It is not my goal to ensure that each person views the world the way I do. This is contrary to the purpose of art and is the antitheses of the individual expression we seek.

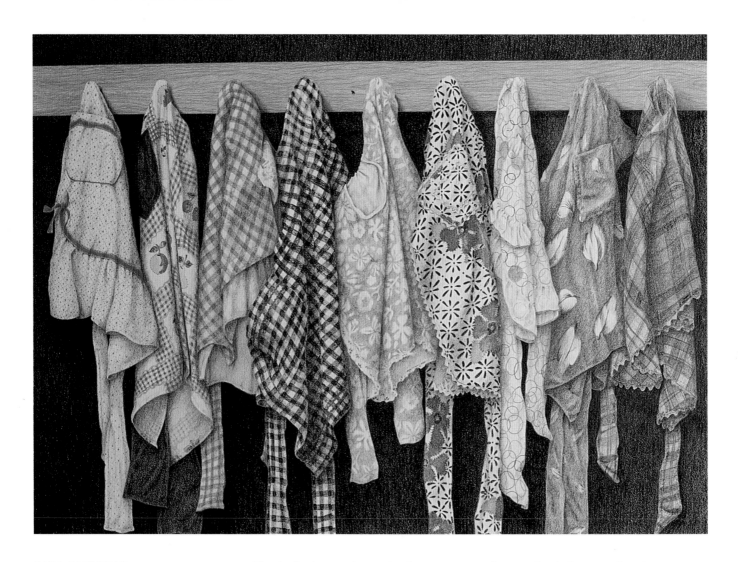

DAVA DAHLGRAN
Any Apron Worth Its Salt Got a
Hanky Pocket
20 x 28 in. (51x71 cm)
Surface Used: Crescent 3-Ply Cold Press Bristol
Board

An unrestricted color palette of warm and cool
hues is used. Dahlgran keeps the background
dark, simple, and unmoving to eliminate conflict
with the various patterns. She completed this
work in approximately 100 hours.

The idea for this piece began when I was given some of my grandmother's aprons. Over the years, others found their way into my collection, and the styles seemed to fall into groups. I made some color changes in the variety of patterns but kept faithful to the original owner's choice of fabrics and style. Once the still life was arranged, I noticed that each apron had a pocket and remembered that the ladies in my grandmother's church circle usually kept a hanky there. The piece named itself before I even began drawing.

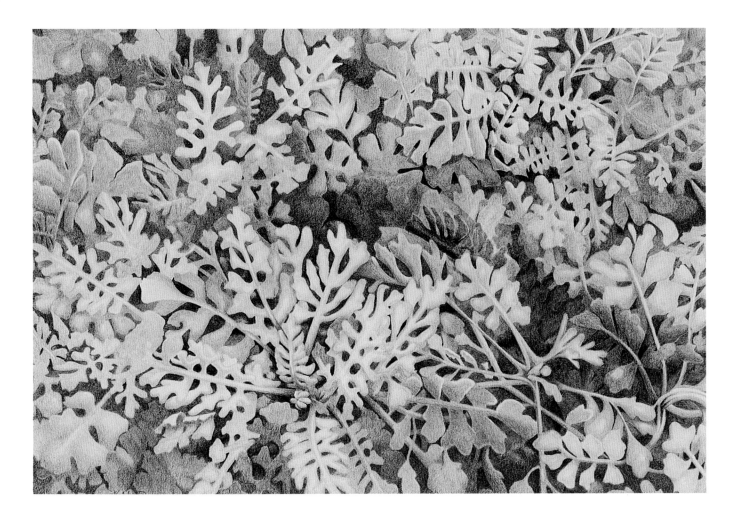

Using black and white film for my reference photograph enabled me to study the values of my subject rather than its colors. As I looked through the lens at the foliage of my Dusty Miller plant, the close-up view emphasized the positive and negative shapes to produce a wonderful depth of field. I felt as if I could almost move into the picture and wanted to capture that feeling in a painting. Since I planted my Dusty Miller among flowers of blue, purple, and scarlet, it reflected those colors. I purposely incorporated them around the natural gray-green of the subject.

KAY MOORE DEWAR
Dusty Miller
21 x 28 in. (53x71 cm)
Surface Used: Strathmore 500 Bristol, White

No burnishing was used in this work. However, Dewar made every effort to fully cover the paper by laying short strokes close to each other and alternating their direction. She used masking tape or a vinyl eraser to lift color as needed.

BILLIE DE LA PENHA
Standing Figure
36 x 24 in. (91x61 cm)
Surface Used: Strathmore 2-Ply Acid-Free
 Bristol Board, White

The colorful background was just the foil de La
Penha needed to push the figure to the fore-
ground and express the relaxed mood of the
model. He applied bold patterns with homemade
stencils and covered with layers of pure color.

My love for working with the human fig-
ure began about thirty-five years ago when
I studied classical drawing and anatomy.
To me, the human body is a technical
phenomenon and emotional challenge.
Each time you draw, you must look at
your model as if it were the first time.
Sometimes we become so complacent
that we draw what we know and not what
we see. The thin, elongated figure posed
against the colorful wall hanging was just
what I needed to make my statement.

This work is part of a series entitled "Echoes of The Dance," where I portray life as theater, with the stage set for the action of the characters. The heroine in her red dress seduces, struggles, and dances with the dark side of life. Death, though not always apparent, is never far away and dances with her throughout her journey. The idea for this work originated several years ago from a sense of the fragility and precariousness of life as well as a personal encounter with deep depression. While I feel that all is temporary and that death always accompanies us, I don't see this as particularly threatening since it has its humorous aspects as well.

ELLEN ROTH DEUTSCH
Snow White Wants to Rest
10 x 8 in. (26x21 cm)
Surface Used: Arches 140 lb. Acid-Free
Lanaquarelle, White

To produce the intense, frenetic feel of the work, Deutsch uses color and line to convey this message. She starts with yellow and then instinctively layers colors in coarse, short hatching strokes. For added interest, graffito lines—created with a sharp dental tool or etching needle—are scratched into the layers.

SHERI LYNN BOYER DOTY
FRIENDS OF CPSA AWARDS
In the 6th Square
19 x 14 in. (48x36 cm)
Surface Used: Strathmore 4-Ply Acid-Free
 Vellum, White

Doty approaches her colored pencil work as she
would oils. She works an underpainting of val-
ues and an overlay of color—intermittently alter-
nating each until she reaches the color satura-
tion needed. A clear blending marker invades
the texture of the paper for rich, dark areas.

As a portrait artist, my work has been defined as Classic Realism. For me, however, the most exciting
subjects are those I create. *In the 6th Square* diverges from my traditional approach with the inclusion
of the fantasy images. This painting combines the real and the imagined—the child portraying Alice is
actually my daughter, the background in the mirror is taken from a park in Australia, the frame is a com-
pilation of advertisements, and the rest of the figures are from my imagination.

The *Magic Ball* is a cover illustration for a proposed children's book. It was inspired by an artist friend, Tony DeLap, who is also a magician. I wanted to create a feeling that the mysterious powers of art and magic were rubbing together, thus the white ball mysteriously rising from the box and casting an eerie glow. The props—my cat Max, postcard images from my studio walls, my son's horse drawing, and a beaded bag from Africa—were all personal and recurring images in the story. The magician's poster of Houdini playing cards with the devil I created from memory.

DOREE DUNLAP
Magic Ball
24 x 20 in. (61x41 cm)
Surface Used: Color-Aid Paper

Using what she calls "helicopter" strokes, Dunlap lays color in spiral motions over Color-Aid paper. This paper is almost impossible to erase without damaging its surface. The point of no return comes once she buffs the surface with a soft cloth. This enlivens the colors, lays down the nap and permanently embeds the wax pigment.

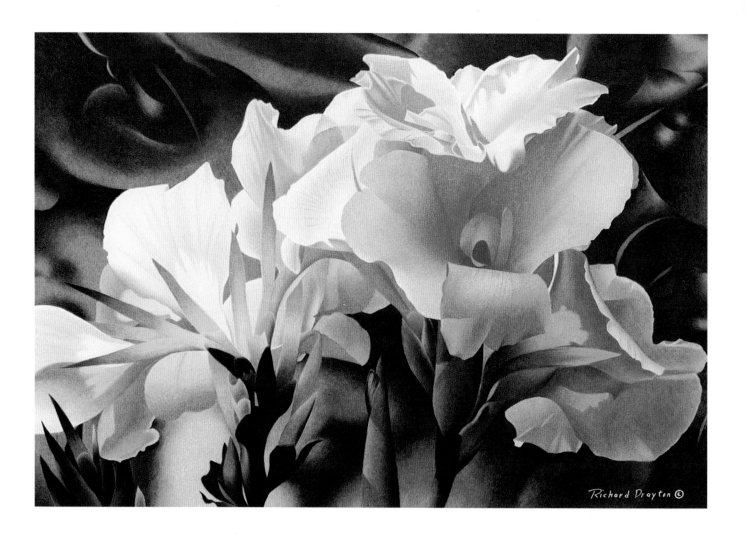

RICHARD DRAYTON
In Full Bloom
19 x 28 in. (48x71 cm)
Surface Used: Strathmore 500 Series 2-Ply
 Bristol, White

The electronic aids Drayton uses to make pre-liminary creative decisions are merely time savers that provide the foundation of his paint-ings. After developing an indistinct monochro-matic image, he completes the painting one pencil stroke at a time.

Every one of my paintings begins in the viewfinder of my camera. I work with at least three, and some-times as many as ten, photographs to create a painting. These photographs are then scanned into my computer. In the beginning stages, I literally develop the painting digitally. This allows me tremendous flexi-bility in determining the perfect composition and inventing a palette—the computer offers over a million color variations to choose from. I then enlarge the image in continuous-tone black and white in my copier to transfer to my drawing surface. From this point on, the process is simply artist, pencil, and paper.

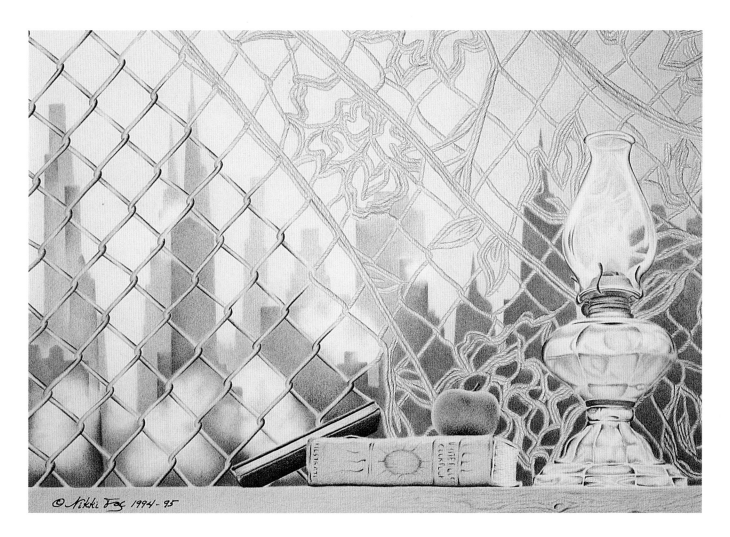

© Nikki Fay 1994-95

I call myself a surrealist. My goal is to depict scenes from a dream or story that appear just out of reach—surreal enough to question reality, yet genuine enough to remain accessible. When the last touches of colored pencils are added, my part of the creative process is complete, and it is up to the viewers to start their travels. More people have made up their own story about this piece than any other painting I have shown. They are adamant about telling me their definition about my painting.

NIKKI FAY
In My Grandmother's House
We Were Always Safe and Warm
22 x 28 in. (56x71 cm)
Surface Used: Rising 2-Ply Museum Board,
 White

The importance that Fay places on the background of her painting leads her to complete it before rendering foreground objects. She uses a time-intensive layering technique of overlapping tiny circles and ovals to obtain a smooth, even finish.

CAITLIN FLYNN, CPSA
Passage in Time
17 x 11 in. (43x28 cm)
Surface Used: Strathmore 500 4-Ply Bristol
 Board, White

After applying an underpainting of earth tones, such as umber, sepia, and grape, Flynn layers colors mixed with French and cool grays. She alternates tonal applications of color with burnished layers of lighter hues. She finishes by rubbing a cloth over the surface for a smooth, paint-like effect.

Specializing in contemporary naturalist themes, I explore the sacred and primal elements in nature as well as human culture. Sacred sites, such as this one located in Chaco Canyon, can validate on a deeper level who we are as humans and clarify our sense of purpose in life. They take us back in time, in history, and are bridges that guide us toward our future. *Passage in Time* represents a doorway back to when we knew the land and how to survive in balance and rhythm with nature.

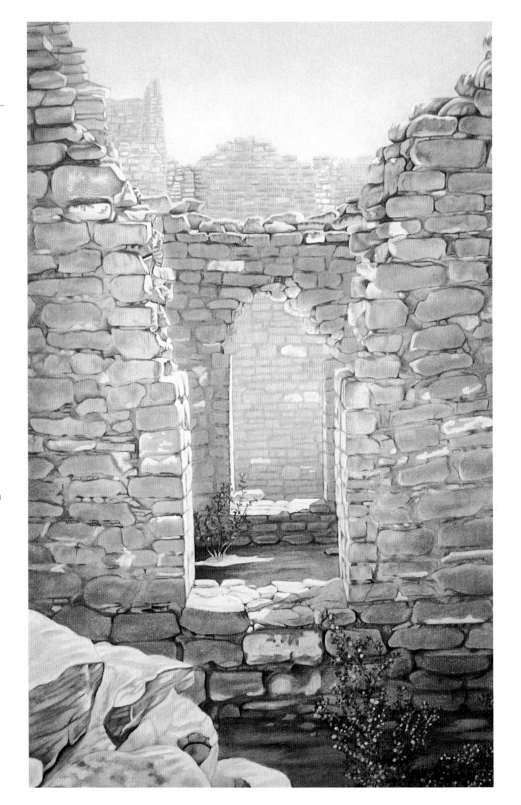

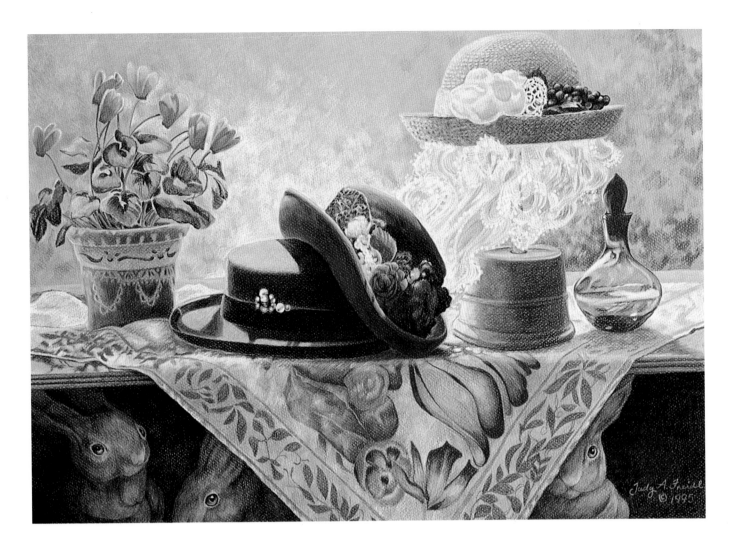

I paint the small and quiet things in life because I believe this world would be as greatly reduced by the loss of fireflies as it would fireworks and shooting stars. So often the small beauties are overlooked and their momentary glow lost forever. That is why I am an artist—to capture those small treasures in a more lasting form. This painting began with my love for hats, with their mysterious, magical qualities. The title emerged early and, in turn, influenced the whimsical intent of the piece. The addition of rabbits not only balanced the empty bottom of the painting but, without conscious thought, played into the theme of the work.

JUDY A. FREIDEL
Hat Tricks
23 x 30 in. (58x76 cm)
Surface Used: Canson Mi-Tientes Paper, Warm
 Gray

With the composition established on tracing paper, Freidel covers the back of the paper with white pastel, positions it over her gray paper, and transfers the work. She uses a hard-lead colored pencil over the white pastel line drawing and then brushes off the pastels.

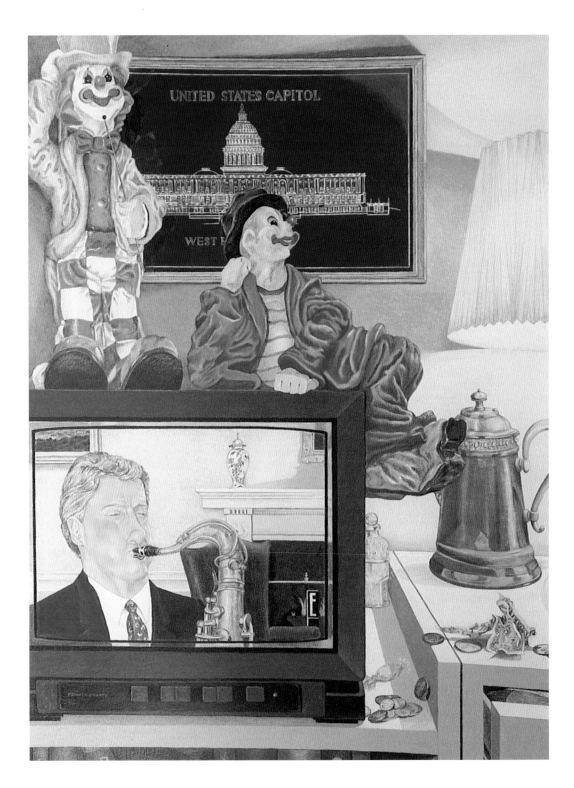

BILL D. FRANCIS
Trio on the Hill
35 x 25 in. (89x64 cm)
Surface Used: Fabriano Acid-Free Printmaking
Paper, Off-White

To add more color over areas with many layers,
Francis rubs the tip of a colored pencil with an
alcohol-soaked swab to soften the lead and pro-
duce a more intense hue. He often uses a
bronze color as a last layer to give a warmer
tone to those beneath it.

This is a commentary on my recent reactions to today's politics. When this scene appeared on the tele-
vision in my room, the paper-mâché clowns that actually sit on top of the set and the blueprint of the
White House on the wall seemed to become a part of the act. This strong impression led me to express
my conception of government. I felt it was necessary to incorporate an event that actually took place
rather than to distort reality with other interpretations. There were concerns about possibly offending
some people, but I was satisfied that I also had my rights of expression.

While I worked in pen and ink for about thirty years, I was always frustrated by the harshness of the medium. Colored pencils opened a new world of expression and finally allowed me to capture the softness and subtlety that had eluded me. In *Love at the Seashore* there is a variety of textures—from rocks and sand to foam and reflections—to allow for a combination of techniques. I wanted to express the feeling of light and translucency and to convey my belief that there is beauty in everything, even two horseshoe crabs doing what comes naturally.

NANCY GAWRON
Love at the Seashore
20 x 24 in. (51x62 cm)
Surface Used: Bainbridge Mat Board, Aztec
Sand

Since the majority of Gawron's work focuses on nature, she prefers the soft natural tones of a colored mat board. This also eliminates the stark contrast that white surfaces can produce. She allows the texture of the mat board to show in various areas to keep the painting from becoming too tight.

DONNA GAYLORD, CPSA
Looking In—Looking Out
20 x 32 in. (51x81 cm)
Surface Used: Arches Acid-Free Hot Press
 Paper, White

To accurately capture horses with hats, Gaylord fashions hats from kneaded erasers and places them on miniature horse statues to serve as her models. She uses various linear and tonal applications to create the many textures in this work.

Those who are familiar with my work are quite surprised when they see this painting and, like myself, wonder "Where did that come from?" In the past, I focused primarily on desert subjects and just recently felt the need to go in a different direction, to change. Since I've always been fascinated by animals and have read *Black Beauty* more times than I can remember, I found this subject creatively challenging. I did not want *Looking In—Looking Out* to be "cute," but aimed at providing an amusing and entertaining approach to the work.

STEFAN GEISSBUHLER
The Slippery Leopard
26 x 20 in. (66x51 cm)
Surface Used: Canson Mi-Tientes Acid-Free
 Paper, Blue

Working with a large palette, Geissbuhler blends the colors into each other for different effects. If he wants to remove a color, he prefers to simply cover it with another hue rather than erase it.

Some things in nature are immediately considered beautiful; others require a second look. I want to encourage the viewer to take that second look. My ongoing fascination with frogs—the translucency of the skin, reflections in the eyes, and wet skin—inspired this painting. This particular frog caught my eye because of its colors and pose. This face-to-face stare made the frog a more active, rather than passive, subject. By emphasizing its presence, I wanted to encourage those who typically don't like frogs to see the beauty behind their slippery surface.

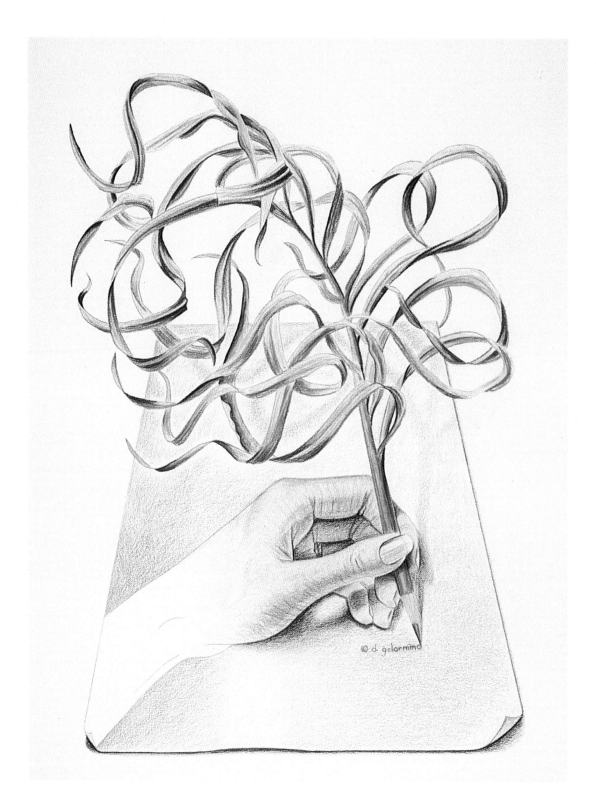

DIANE GELORMINO
The Signing
18 x 14 in. (46x36 cm)
Surface Used: Arches Hot Press Watercolor
 Paper, White

Gelormino keeps the simplicity and movement
in this illustration by using bright colors and soft
shapes. She allows the various hues to remain
unblended to retain the look of a drawing.

This illustration began with a dying frond on my palm plant. Because its intertwining curled shapes
reminded me of a large feathered pen, the concept for the rest of the drawing just evolved. I incorporated
a combination of two- and three-dimensional renderings and used my signature as part of the picture to
capture a surreal feeling.

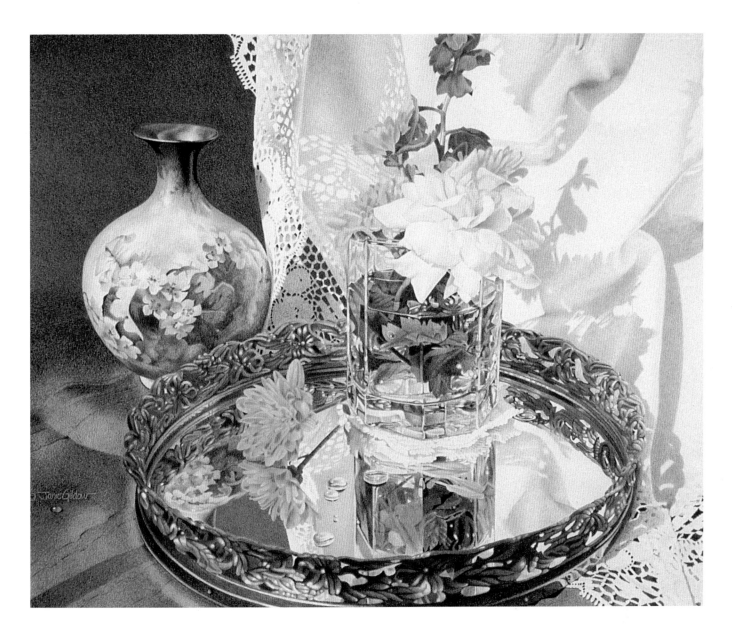

The very structured, calculated way I work is not for everyone; however, I was born with unending patience and enjoy detail. My extensive planning of the composition and palette selection is a large part of my creative process. Once I begin applying the color, I work very carefully and complete about one square inch per hour depending on the complexity of the drawing. This painting took 165 hours to complete. My work is very straightforward; there are no innuendoes. Many people miss the wealth of detail that surrounds them. I simply want to call it to their attention through the illusion of realism.

JANIE GILDOW, CPSA
Lace Reflections
15 x 17 in. (37x45 cm)
Surface Used: Crescent Hot Press Board 115, White

Gildow creates several lead-ins to the focal point of the tumbler: the lace shadows and edges, the line pattern in the green fabric, the oval arms of the mirrored tray, and the shadows on the white fabric. The patterned vase becomes a secondary accent, repeating the flower and leaf forms and the oval shape and brassy gold of the mirror.

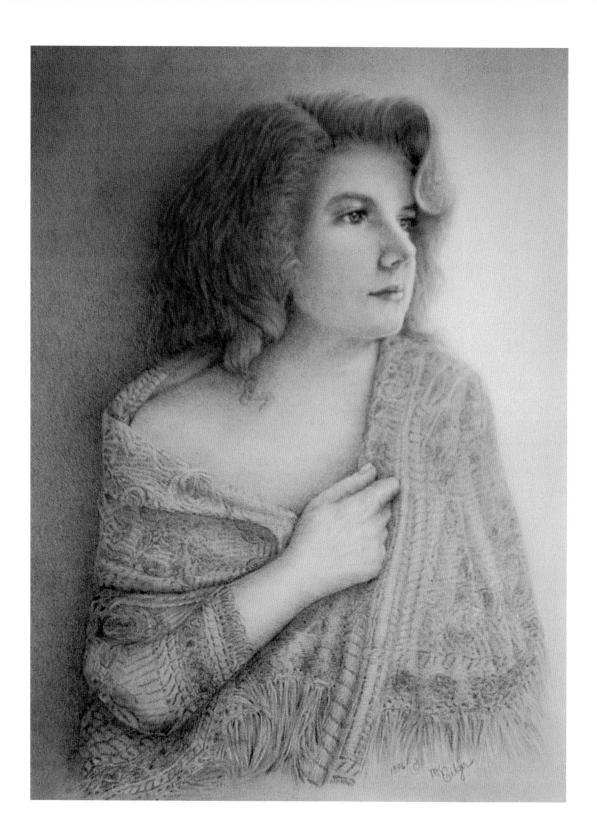

MARSHA GILGER
The Piano Shawl
24 x 18 in. (61x46 cm)
Surface Used: Windberg Panel, Gray

After two weeks of detail work, Gilger decided
the shawl overpowered the woman and the
intended mood. She used a kneaded eraser and
fine steel wool to distress the detail until it was
only a suggestion. Colored pencil covers the
entire surface.

I have never been one to develop a particular style or to paint in a series such as "Apple on a Cube 1 through 150." I'm inspired by all subject matter, lighting, color, detail, or composition. In *The Piano Shawl,* I created special lighting to set a mood. My intent was to focus on the contrast between the age and texture of the shawl and that of the young woman. I almost ruined the delicate balance by rendering too much detail in the shawl and had to stop and remember just what my original goals were in this painting.

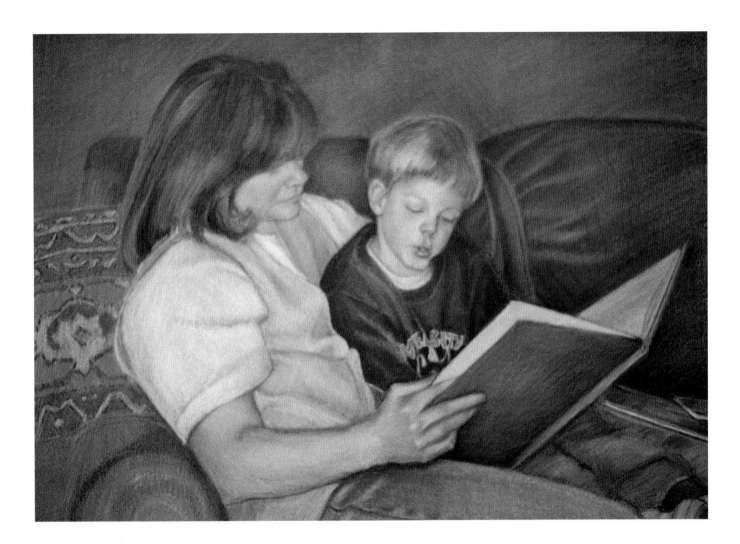

What initially motivated me to capture this moment were the shapes made by mother and son and the low light that created a pensive and loving atmosphere. My goal was to capture this mood without being overly sentimental and pedestrian. I also wanted the figures to be part of the overall composition and not to appear cut out and pasted on. Once I broke the scene into large abstract shapes with light, dark, and mid-tone values, I put the reference photographs away so I wouldn't be tempted to duplicate them exactly.

CISSY GRAY
The Last Story
12 x 18 in. (31x45 cm)
Surface Used: Canson Mi-Tientes Paper, Steel Gray

By placing ten layers of newsprint beneath her paper, Gray buffers the hardness of the drawing board for a "springier" surface. This eliminates any hard lines from the pencils, reduces wax build-up, and results in softer color blends.

SHERI GREVES-NEILSON
Rachel

16 x 12 in. (41x31 cm)
Surface Used: Rising 4-Ply Acid-Free Museum
 Board, Cream

Using a limited palette, Greves-Neilson stays
as close to the complementary colors of yellow
and violet as possible and lets the cream paper
show through to unify the work. The dark back-
ground is slightly blended with a kneaded eraser.

While my work is usually very western and
equine, I wanted to do a soft feminine
piece that would also appeal to the audi-
ence that frequents the galleries represent-
ing me. When I draw people, I attempt to
show their spirit as well as their likeness.
This young girl, herself an artist, is sensi-
tive and gentle. I wanted the drawing to
express this. By fading the detail of the
blouse and eliminating the busy pattern of
the hat, the focus centers on her face and
delicate hands. This creates a dramatic
presentation within a simple composition.

The absence of people in a scene can somehow lend an air of mystery to it. This area in Sedona, Arizona, has been described many times as a spiritual place. It is shown here pretty much the way I photographed it—the colors in the sky and rocks are exactly as I saw them. You cannot improve on nature's creations. However, when they are confined to a rectangular space that will be surrounded by a frame, compositional problems can be encountered. I shift some of the objects slightly and rearrange other elements. I have no formula for doing this. It is mainly an intuitive process.

ROBERT GUTHRIE, CPSA
Bell Rock, Sedona
6 x 30 in. (15x76 cm)
Surface Used: Mylar Transparent 5 Mil Matte
 Drafting Film

After the drawing is transferred to transparent Mylar, Guthrie creates a gray value study on the back side of the film. He scrapes blue art sticks on a kitchen grater and rubs the powder into the cloudless sky area. He then layers the front of the Mylar with colored pencils and art sticks.

As art guided me through life, humor carried me. I chose this composition because of its interesting negative space—a wide horizontal which lends itself to the large mass of the continuous brim. The eyes, looking directly at the observer, are the eyes of my dedication. And when placed in a gallery, they will look at the viewer who is taking the time to look back at me. My life has always been filled with things that could easily distract from my art—changes, children, challenges. But I kept my gaze steady on art throughout, and that steady gaze is the focal point of this painting.

RITA LUDDEN
Ol' Four Eyes in Black
12 x 20 in. (31x52 cm)
Surface Used: Strathmore 1-Ply Acid-Free
 Bristol, White

As in all of Ludden's paintings, this work is based on abstract principles of line, form, negative space, color balances, and values. She is careful to form the reflections on the glass into interesting shapes without distracting from the gaze of the eyes.

SUSAN E. HAAS
Portrait of Peter
22 x 17 in. (56x43 cm)
Surface Used: Strathmore 3-Ply Bristol, White

Haas works with very thin wax-based colored pencils. These hard-leaded pencils make crisper lines and sharper edges than the softer leads. They also lay down less pigment so wax bloom is eliminated. To add texture to the hair, Haas streaked, rolled, and dabbed it with a kneaded eraser.

When I finally had the luxury of doing some artwork for myself instead of others, I chose to paint this portrait of my 10-year-old son, Peter. I found a picture taken during a cherished trip to the beach with our family. His warm smile and sunny complexion was all the motivation I needed. Even though I eliminated the background references of the photograph, the painting still reminds me of our wonderful days at the ocean. The focus is kept directly on the subject while still expressing his carefree mood on that summer day. Doing Peter's portrait was a labor of love.

I like to paint serene subjects that aren't always noticed in the hustle and bustle of the modern world. A cat cleaning itself is very soothing to watch—the slow rhythm of it is almost hypnotic. I liked the shape and curves of this particular cat and decided to emphasize them by placing the subject by a hydrangea. The clumped shapes of the flowers repeated the patterns of the calico's patches and the purple blues of the petals complemented the orange of the cat's fur.

TANYA HARVEY
Calico and Hydrangea
20 x 14 in. (51x36 cm)
Surface Used: Rising Acid-Free Museum Board,
 White

The directional movement of the fur is created with short hatch strokes which Harvey applies loosely and leaves visible. She sharpens her pencil often during the latter stages of layering to refine smooth areas or to clean up edges.

CARLYNNE HERSHBERGER
Twilight
16 x 11 in. (40x28 cm)
Surface Used: Canson Mi-Tientes, Grayed Purple

The composition is uncomplicated and intimate.
Hershberger puts the strongest light on the
flower and applies muted colors to the back-
ground. The simple vine and leaf in the lower
left balances the top heaviness of the vertical
format.

The most important decision I ever made
in art was to do what I love. I have tried
doing what people say will sell and have
tried the "shoulds" I imposed on myself. It
just doesn't work. Only when I paid atten-
tion to what I really wanted to do, did my
work progress. Another thing that doesn't
work for me is a lot of preliminary thumb-
nail sketches. If I spend too much time
making one drawing after another, I lose
the initial excitement during the final
work. I have to just jump right in.

Let Me Show You... is the result of my fascination with the constant beauty of childhood. An old family snapshot, hastily taken of a brother and sister engrossed in the fantasy of a book, served as the inspiration for this piece. The mood is emphasized by the entire image being bathed in sunlight. No changes were made to the original reference source. That small snapshot, taken so many years ago, perfectly captured the children's freedom, innocence, and adventurous spirit through their body language, play-clothes, and tousled hair. We can all identify with what this painting conveys: "We have been there."

SHARON PRATT
Let Me Show You...
14 x 19 in. (36x47 cm)
Surface Used: Rising Stonehenge, White

By writing a sequential list of pigments she uses, Pratt can duplicate her palette in other sections of the work. To distinguish the textures in the two fabrics, she lightly applies a very sharp pencil to the boy's sweater and uses coarser strokes with a dull, flat-wedged point for the girl's clothing.

LAURENE PULS
Tranquility
12 x 18 in. (31x46 cm)
Surface Used: Crescent Mat Board #8516

Puls uses a dressmaker's disappearing ink marker to draw a grid on the drawing surface. These lines fade away in two to three days and eliminate having to erase graphite lines. Strong light speeds the fading process. The soft-tipped marker avoids impressing lines or damaging the tooth of the paper.

Over time, I learned more about turtles, terrapins, and tortoises than most people want to hear. When my emotions run strong, I dream in turtles. While I'm not cognizant of the powers turtles have in my subconscious, I know they convey feelings of joy, safety, and comfort. I developed rheumatoid arthritis several years ago and have learned to cope with pain through visualization. The warm protected pool of water that I floated through to escape pain, fear, and fatigue is represented in *Tranquility*.

Have you ever let your mind wander past the corridor of reality—out through the open window to fantasy? This is the landscape in which I often find myself. Desperately trying to regain a minuscule part of that other world. You know the one. At least you used to. Once as children, we would pretend. We were read fairy tales, and we believed! This world that has grown up around me smothers out those childhood abilities. The sense of something missing or askew prompts me, even beckons me, to look back—to open the windows of my mind. If I can pry open the shutters that entrap another, my endeavors are well worth it.

MIKE RUSSELL
WALTER FOSTER PUBLISHING INC.
AWARD
Song of Nature
14 x 14 in. (36x36 cm)
Surface Used: Crescent 900 Series Mat Board, White

Russell applies thick layers of pigment with a heavy hand, changing the surface texture of the paper and obliterating its color. He uses the pencils as if they were paint—building color layers until he can push and blend them.

JAN RIMERMAN, CPSA
Anticipation
18 x 28 in. (46x70 cm)
Surface Used: Rising 3-Ply Bristol Vellum,
 Antique White

"Anticipation" illustrates a stylistic quality that appears in most of Rimerman's work. This composition emphasizes the divisions of negative shapes in the background that give the work an abstract appearance. She uses primarily a cool palette with complementary color accents.

The lines and ropes in this work give me an opportunity to create color and magic in the background. While this can be intimidating to some artists, for me, the background is the dessert, and I always develop it first. Sometimes I get bored and have a difficult time finishing the subject matter. As an artist, I take every liberty to push and pull the color to exaggerate the value and contrast for the quality of the piece. The energy that floods over me as I'm working on a painting is overwhelming. I put everything, reasonably possible, aside and concentrate my heart and soul into the work.

After a family problem shook me emotionally and left me drained and uninspired, I stayed away from my drawing table for over a year. I began doing a lot of soul searching and studied the Buddhist art of India, Tibet, and Japan. I was attracted to the mandalas and motivated to do my own so I would have an image to focus on during meditation sessions. I like the serenity and stability this work evokes despite the fact that the whole image rests on a point. The challenge in this monochromatic scheme was the detailed floral design found in the wide band that takes up most of the picture. It was not a technical problem, but a real test of my patience.

MUTSUMI SATO-WIUFF
Tara
26 x 26 in. (66x66 cm)
Surface Used: Canson Mi-Tientes 98 lb. Acid-
 Free Paper, Felt Gray #429

To capture the look of old-world art, Sato-Wiuff draws the circles freehand rather than use a compass. She worked on a mid-tone gray paper using only black and white colored pencils.

ANNA MARIE ROBBINS
Cosmos
8 x 10 in. (20x25 cm)
Surface Used: Crescent Acid-Free Mat Board,
 Rust

To keep the simplicity and contrast in the work,
Robbins uses a limited palette of violets, greens,
and reds and employs a narrow range in each
spectrum. She applies small circular strokes to
fill in the texture of the surface.

I am always on the lookout for images that convey both simplicity and contrast, a combination that often produces powerful colored pencil paintings. With these parameters in mind, *Cosmos* was conceived. I saw a group of lavender-colored wildflowers beside a rust-colored, rough-cut wood fence. The uncomplicated small grouping of flowers and the wood grain of the fence seized my attention. The elements of the composition were chosen and arranged to focus one's attention, rather than defuse it over a wider area.

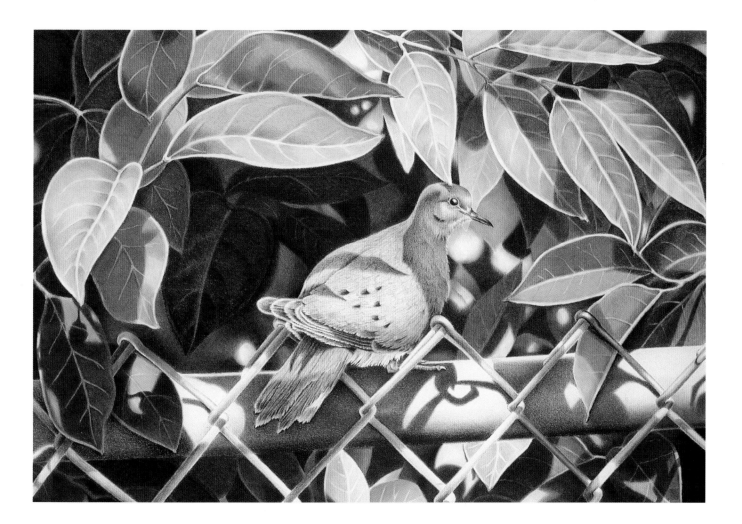

The biggest decision I had to make in *Morning Shadows* was leaving the dove in the very center of the format—realizing that this is often frowned upon in the art world. But I felt there was enough variety in the surrounding shadows and leaves to offset the centered image. Plus, it is fun to be rebellious at times. The dove had briefly landed on the chain-link fence, sheltering himself in the shadows from the oppressive Arizona sun. Then he was gone. I liked the spontaneity of the moment.

ELLY SANDS
Morning Shadows
15 x 20 in. (38x50 cm)
Surface Used: Strathmore 500 Series 4-Ply
 Paper, White

The high key of the dove complements the subtle coolness of the chain-link fence. Sands applied every shade of green available in the colored pencil brand she uses to give the leaves a sun-drenched, waxy appearance. Only the dove was left unburnished.

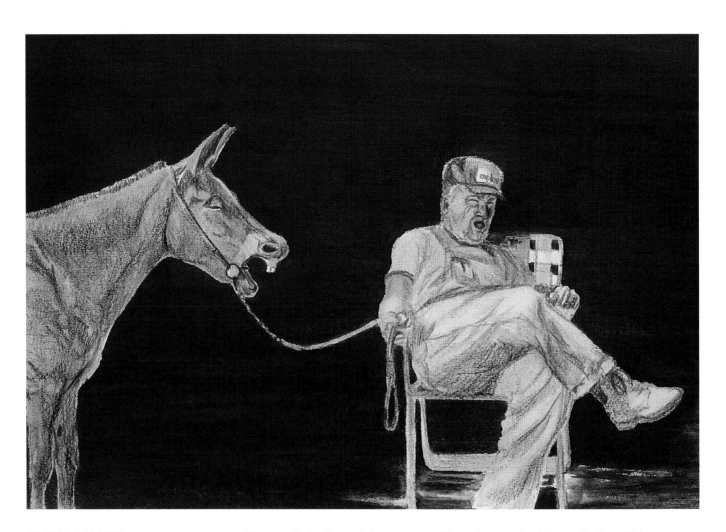

CONNIE SANOCKI
Doubly Bored
17 x 20 in. (42x50 cm)
Surface Used: Arches Hot Press Watercolor
 Paper, White

Sanocki makes preliminary drawings of each
image on separate pieces of tracing paper. She
then arranges the pieces in different positions
to decide on the final composition. The back-
ground is a combination of dry black and indigo
blue layers covered with a wash of water solu-
ble black pencil.

Having worked with animals for many years, I know the strong bond that can be formed between peo-
ple and their animal companions. I thought it comical in *Doubly Bored* that the man and donkey had
mirrored expressions. It seemed their companionship was so close that they felt and reacted similarly.
The composition is strong through its simplicity, and the dramatic light demands attention. Although the
colors are subtle, there are many of them due to the direct and reflected lights. I believe I approached
this subject somewhat differently than other artists might and captured the close relationship of the man
and animal.

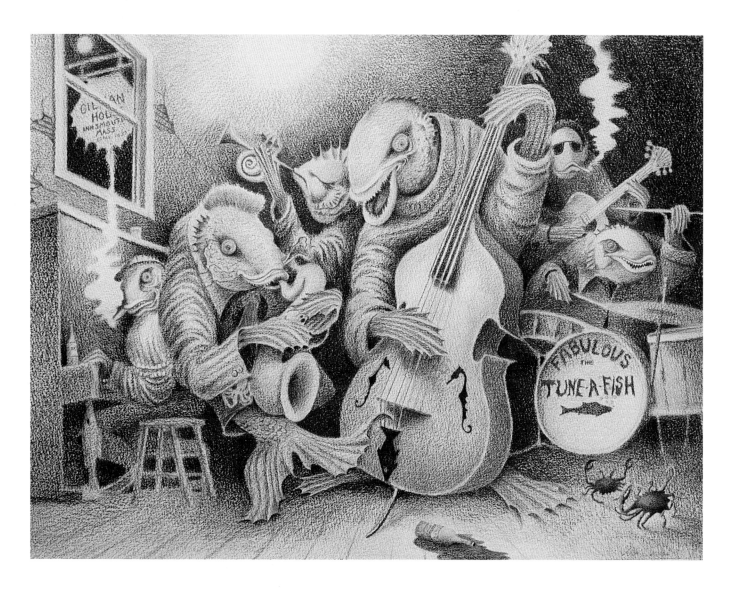

As a teenager, I was drawn to the bizarre and moody writing of H. P. Lovecraft. I was particularly taken with his mythic town in Massachusetts named Innsmouth. Peopled with odd, repellent fish or frog-like beings of ill repute and a brooding, dark atmosphere, it's not a place many would want to stay overnight. Even though Lovecraft didn't refer to the particulars of my drawing, and his stories are far from humorous, I felt that the run-down hotel, The Gilman House, could use a band. This drawing is quite a departure from my mainstream work, and I am intrigued by the possibilities.

ALLAN SERVOSS
The Fabulous Tune-A-Fish
22 x 30 in. (56x76 cm)
Surface Used: Arches 300 lb. Cold Press
 Watercolor Paper, White

A series of sketches were needed to develop these odd little characters. Servoss began the composition with only the two central figures and improvised the rest of the drawing as it progressed.

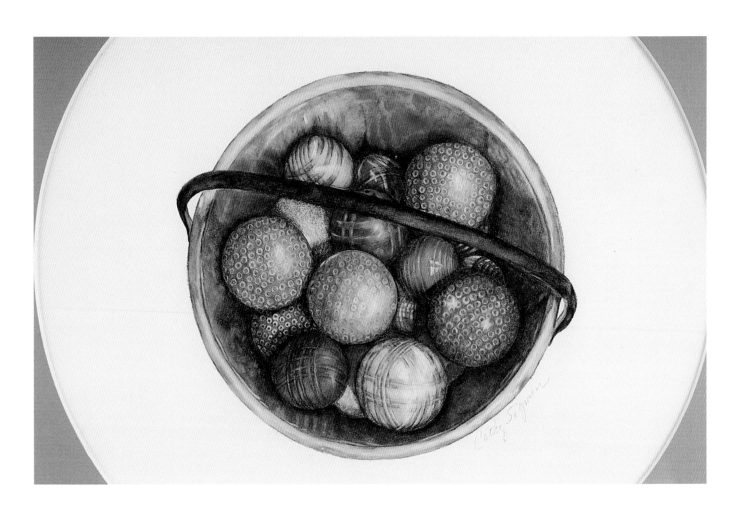

CATHY J. SIGMON
English Carpet Balls
15 x 15 in. (38x38 cm)
Surface Used: Arches 140 lb. Acid-Free Cold
 Press Watercolor Paper, White

Black and white photocopies of her photos
enable Sigmon to see the range of values in the
subject. She often places her pencils in the sun
to soften the wax-based pigment or will harden
the leads by leaving them in the refrigerator.

While browsing at a flea market, I noticed a copper bucket filled with porcelain balls. The color, simplicity, and uniqueness of them instantly appealed to me for a colored pencil painting. I realized that at $125 each I could not afford to purchase them. The vendor graciously allowed me to photograph the balls and even threw in a brief history lesson. I learned that these beautiful hand-painted porcelain balls were used for indoor lawn bowling during the Victorian period in England—until the bowlers realized how fragile they really were. I hope this painting stirs the same curiosity and interest in the viewer as it did for me.

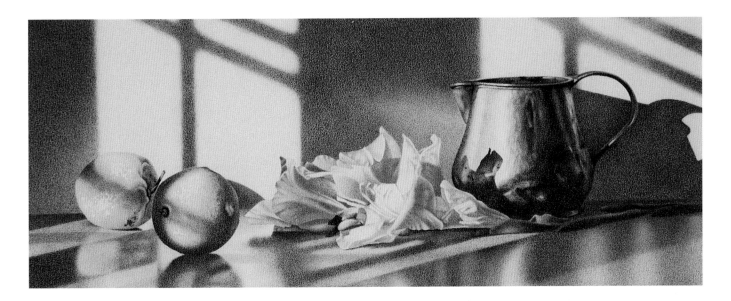

My artistic goals are quite simple: To please myself first and then to sell the work. Whether it's a land-scape or a still life, a place or a mood, I paint where I want to be. By recreating a scene or a feeling, I can relive the experience through my art. This painting came to me one morning through my dining room window. The quiet mood it created was like my own. Perhaps on another day, with another frame of mind, I may not have seen the beauty of it. The colors motivated me first. And the cool shadows, the warmth of the wood table, the soft sunlight all spoke to me on that day.

LAURA WESTLAKE
A Marriage of Families
9 x 21 in. (23x53 cm)
Surface Used: Strathmore 3-Ply, Acid Free
 Bristol Vellum, White

Westlake's fine tonal application gives the appearance of a soft stippling technique. But this effect results from a combination of the vellum-finish surface she uses and her extremely light application of pigments. This painting took approximately 40 hours to complete.

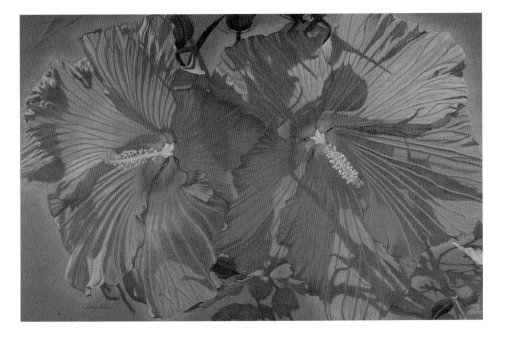

CLAUDIA JEAN FARLEY
Hibiscus Morning
23 x 32 in. (57x80 cm)
Surface Used: Crescent 100% Rag Mat Board,
 Rubia

Farley's first intent was to allow the color of the board to serve as the shadows in the flowers. As the work progressed, however, she found that the contrast between light and dark became deeper and more defined when color was lay-ered in all sections.

My art has been a sanctuary for me during my thirty-six-year professional business career. It is what I did in my spare time to keep me calm and on an even keel. Now retired, my art takes on a much deeper meaning and is my way of sharing what I see and how I feel about life.

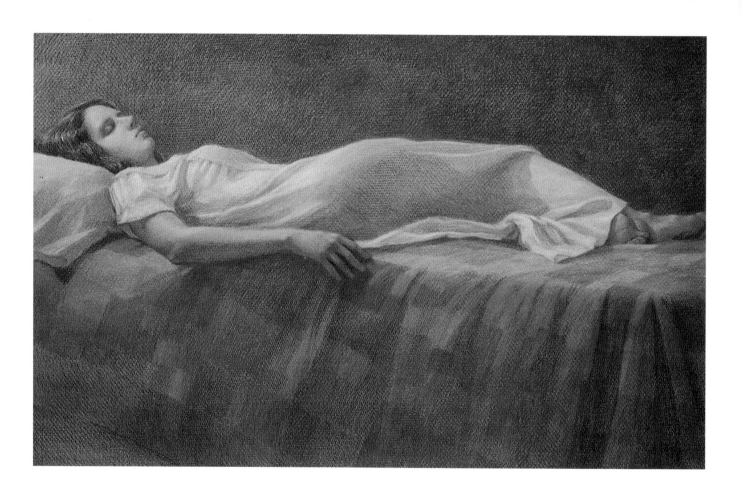

RITA MACH SKOCZEN
Enter the Night
21 x 32 in. (53x81 cm)
Surface Used: Strathmore Drawing Paper, White

Drawing from a model, Skoczen begins each
painting with the subject and resolves the fore-
ground and background upon its completion.
Visible pencil strokes provide the look of a
raised texture while burnishing the highlight
areas creates smoothness.

I enjoy the stimulation of working from a live model. I am in charge of hiring, dressing, and posing a
model for a life study group of five artists. Much time is spent in placing the model in an interesting
position, retaining a flow to the contours of the body and folds of the costume. Setting the proper light-
ing is the last element that sets the mood. The whole scene must be visually stimulating to me.

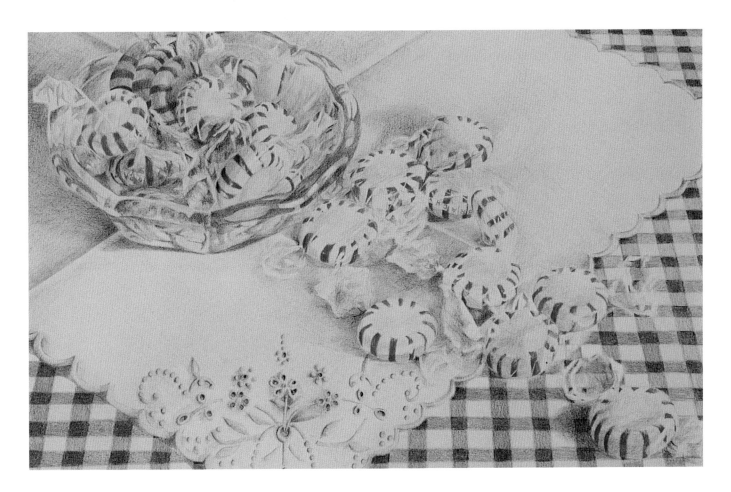

Realism is not the same as photography. As one who paints realistically, I feel an artist can come to know and decipher a subject to depict a new meaning. In *Peppermints*, the subject is familiar, yet the line, light, and composition allows a closer look at shapes, hues, and form. I don't make changes in what I see, but try to communicate to others exactly what I have observed.

ANNE RENARD SMITH
Peppermints
20 x 27 in. (49x66 cm)
Surface Used: Arches Hot Press Watercolor
 Paper, White

Smith prefers to draw her subjects in a larger-than-life format to emphasize details. She works colors light to dark, building one darkest area first to help establish values.

SHARRON E. SMITH
Dad's Tools
8 x 10 in. (20x25 cm)
Surface Used: Crescent Acid-Free Mat Board,
 Classic Brown

Because Smith feels she cannot get the shadow areas dark enough on a white surface, she chooses to work on a colored ground. She applies a fine crosshatching stroke with soft-leaded colored pencils and uses hard lead pencils over them to blend the layers and smooth the surface.

It took a long time to even classify myself as an artist let alone define the reasons I should claim such a title. After fifty-odd years of wrestling with many identities—woman, wife, mother, etc. I finally realized that "artist" was appropriate. Early on, I felt the need for creative expression. I was blessed with parents who understood that need. I see everything as it might be painted. I look for how the light effects an object and especially how it casts shadows or reflections on a smooth surface. Still life arrangements excite me. I tend to get lost in the details, then I fight to pull myself out and concentrate on the overall elements of the work.

Sunflowers is charged with intense colors and contrasts, but my primary interest in drawing the flowers was the many variations in texture. I grow sunflowers in my wildlife habitat backyard, where birds flock to feed on seeds. Growing up in the country, I was familiar with animals and their habitat, and they have always been an easy subject for me. I have lived in cities in recent years, but puttering in my garden is always a source of inspiration as well as a welcome diversion.

CAROL SORENSEN
Sunflowers
20 x 22 in. (43x48 cm)
Surface Used: Arches 140 lb. Watercolor Paper,
 White

Similar to a scumbling technique, Sorensen uses a dirty, hard eraser to tone, haze, and dull colors in various areas. Regardless of the subject, she liberally applies orange, sienna, purple, and indigo pencils during the final stage to avoid being too literal with her color applications.

SCOTT M. SNOWMAN
Camoflauge IV
30 x 20 in. (76x51 cm)
Surface Used: Crescent #100 Cold Press
Illustration Board, White

After a few months, Snowman finds that the wax-based pigments covering the surface become resistant to any further blending—even when the layers are scraped. Using a blow dryer in a circular direction, he heats the surface to gently soften the wax enough to scrap the layers. New layers can then be added and blended.

My father was an art teacher, and I grew up watching him paint and do wood sculpture. I took classes from him in high school and met my future wife in that setting. Now I teach art in the same school in which my father taught for over thirty years; my wife is an art teacher at the community college. I feel the influence of art all around me and find great motivation in the fact that I have so many people to share my passion with. My most important goal as an artist is to capture the things I love in my own way.

Working with a tight deadline, the calendar assignment was to create thirteen still life illustrations with a monthly related home and food theme. A cold, crisp slice of juicy watermelon sure said July to me. It was important that the image convey "hot summer day" and leave the viewer no doubt as to which season they were experiencing. To further reinforce the summer feeling, I placed the watermelon on a yellow Adirondack chair. Excited by the contrast of the watermelon's rounded forms against the chair's straight lines, I purposely cropped the chair for emphasis.

JEAN K. STEPHENS
Hot Summer's Day
16 x 15 in. (41x38 cm)
Surface Used: Canson Mi-Tientes Paper, Buff

Since this image is for reproduction, Stephens takes care to ensure that the strength of the values and intensity of the colors hold up in separation and printing. She uses a warm middle-toned paper to build light and dark values.

MARDI SPETH
The Balloon King
16 x 16 in. (41x41 cm)
Surface Used: Color-Aid Paper, White

The dark sky border is the most time-consuming area. Speth applies over twenty-five layers of color, using a small figure-eight motion in various directions, around the white star shapes. She cleans and sharpens the stars with an electric eraser, template, and X-Acto knife.

My 5-year-old son Michael loves balloons. Whenever balloons are in the house he starts dancing and jumping around them. They bounce off of everything, float so gracefully, and are so colorful that the mere sight of balloons brings smiles. I wanted to capture that exuberance and freedom, that child-like energy. With an idea for a story and the unfaltering persistence of my friend, Doree Dunlap, I wrote a story for my son. *The Balloon King* illustration will be the cover for that book.

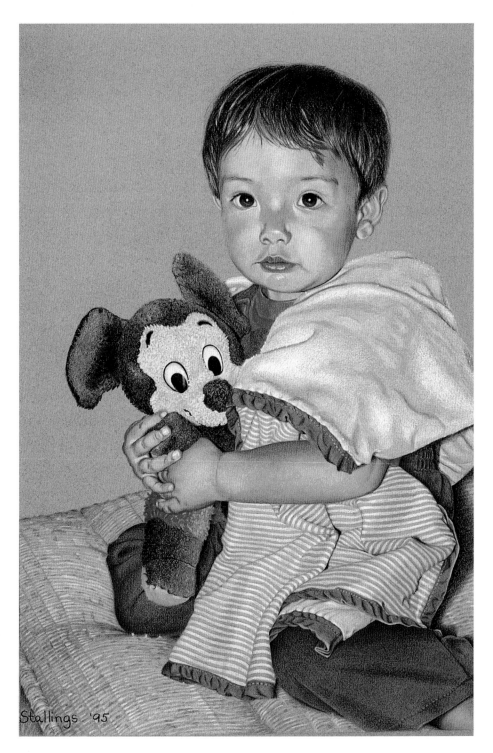

Stallings '95

I work professionally with children and am drawn to all things which capture the essence of childhood. It is predictable then that I would first choose to do portraits of my children. Although my son is now a teenager, *Transitional Objects* comes from my favorite family snapshot. By eliminating extraneous and distracting details in the background, I was able to create a formal portrait from a casual photograph. During the months I worked on the piece, I was able to go back in time, in my head and my heart, to once again be with that little boy.

SHIRLEY STALLINGS
Transitional Objects
21 x 14 in. (53x36 cm)
Surface Used: Canson Mi-Tientes Paper, Felt
 Gray

To avoid the look of a hard surface on the plush toy, Stallings first experiments with the texture before deciding to use a circular motion. While the gray paper works well with the upholstery and background, it requires extra layers of color to keep skin tones from looking drab.

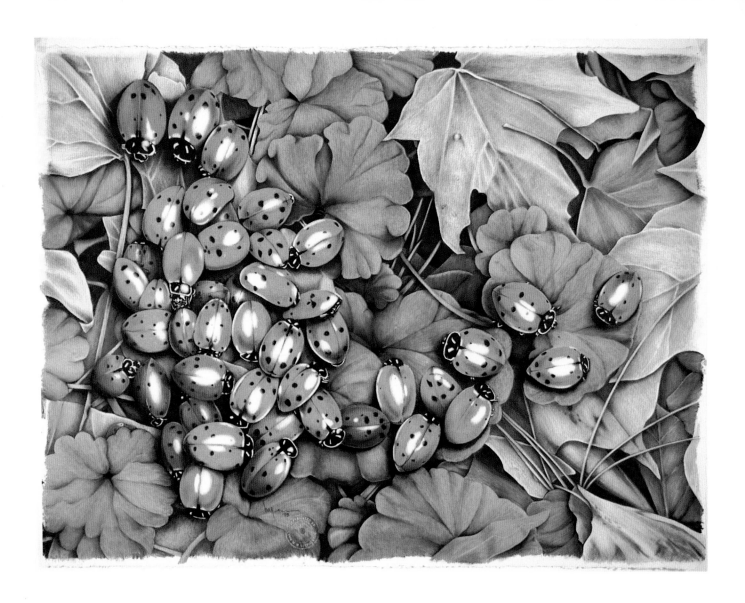

LYNN M-W STEPHENSON
Ladies
31 x 38 in. (79x97 cm)
Surface Used: Arches 300 lb. Acid-Free
 Watercolor Paper, Cream

This work was initially completed with a blank background using the subject as an abstract pattern. Later, Stephenson decides to add content to the work and integrates a background around the established subject.

As most artists would like to say, but fear being mistaken for a piece of furniture, I am a drawer. I am also a purist in the colored pencil sense. I don't use graphite, except for the initial sketch. I don't use any solvents to mix colors. I let the paper surface serve as the highlights, except when the entire piece is burnished. When I burnish, I use colors, not white. *Ladies* was an inspiration from nature. Attracted by the repetitive shapes and the abstract composition they created, my intent was to show their inherent beauty. I didn't need to change the bugs; I didn't need to make them something they were not.

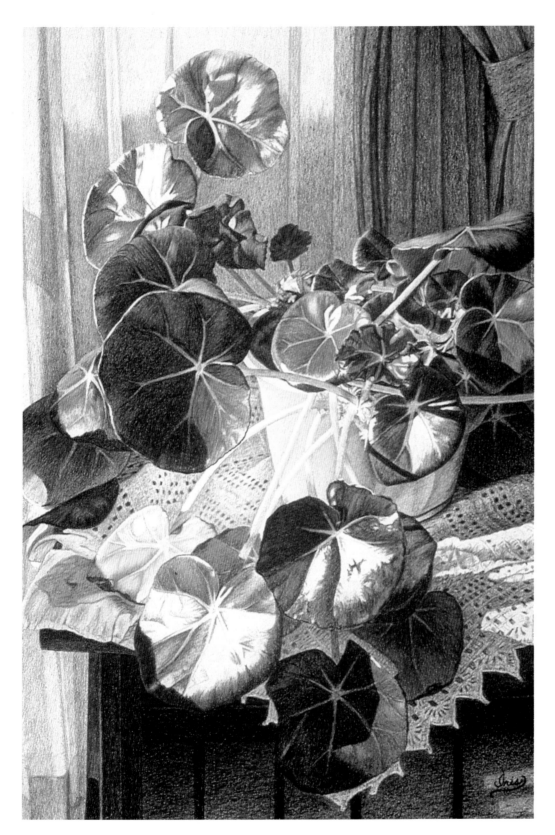

IRIS STRIPLING, CPSA
Favorite Begonia
12 x 9 in. (31x23 cm)
Surface Used: Lanaquarelle 140 lb.
 Hot Press Watercolor Paper,
 White -

To create a still life with strong contrasts, Stripling photographs her subject in a sunny south window. After tracing the photo image onto clear acetate with a fine-point black pen, the artist enlarges the outline on a photocopier to the desired size and transfers it to the drawing paper.

An avid gardener for many years, I am inspired by the beautiful detail God has woven together to create our world. I find limitless ways to express these images through my artwork. I particularly wanted to capture *Favorite Begonia* at this stage of growth. I often repot this houseplant, and each time I do I almost kill it. It takes some time to regain the healthy vigorous growth pattern that inspires me to paint it. I work in a realistic style and wanted to capture the warmth of the sun and a sense of "being there."

DON SULLIVAN
Portrait of a Friend
11 x 8 in. (28x19 cm)
Surface Used: Canson Mi-Tientes Paper,
 Light Gray

To set the mood, Sullivan uses blues and grays in the background for a quiet, lonely feeling in the little room. The light from the window contrasts that blue feeling and frames the subject.

The work I do for myself comes from absentminded doodling. The man in *Portrait of a Friend* appeared from one such doodle, and I liked his face. As I played with the sketch, the man's posture and what he was doing just seemed right. It felt natural that he be feeding a sparrow some of his green peas. Nothing unusual. But it is curious that the peas are shared from a coffee cup with the bird sitting on a spoon. Is that window open? Did the sparrow fly in? Does the bird have a cage? Or does the man feel caged? You don't need the answers to enjoy the scene.

Many of my ideas are born and refined while out jogging. In the case of *Sugar Bowl,* it was the middle of November, and I needed ideas for a holiday greeting card project. For some time, I wanted to incorporate my mother's old coffee service in my work. As I jogged along that morning, images began to form of the opalescent and silver trim of the ceramic set. Thoughts of "what if" came to play: What if... the sugar bowl spilled? What if... the sugar was actually snow? Childhood memories of snowy days made their way into the work, and I felt pure joy while creating it.

KAYE A. SYNOGROUND
Sugar Bowl
8 x 10 in. (20x25 cm)
Surface Used: Rising 2-Ply Museum Board,
 White

Synoground draws the composition directly on her paper surface. This undersketch must be applied very lightly so that impressed lines are not left on the soft board. She uses Tuscan red which is easy to see and can be removed with a kneaded eraser.

CAROL TOMASIK
Tess in the Temple of Winds
34 x 25 in. (86x64 cm)
Surface Used: Crescent Mat Board, Medium
 Cool Gray

Tomasik creates grid-like frames to divide the
space into sections. While the sections are uni-
fied by overlapping grids, each panel remains
separated with narrow strips of gradated color.
Nothing is burnished, sprayed, erased, or manip-

To say that nature or color motivate me as an artist is an understatement; it is more like they possess me. Just show me a field of tall grass, or a thundery cloudscape, or the colors in a new box of crayons and I am powerless to resist. I had always considered the stark look of England's Stonehenge to be the perfect subject for a painting. Something about the regular, massive stones contrasted against a soft, wispy sky intrigued me. I wanted to create an illustration; something more than just a postcard image of a famous landmark.

RONNI WADLER
Watermelon
28 x 18 in. (71x46 cm)
Surface Used: Canson Mi-Tientes 1-Ply Paper,
 Brown

Wadler creates drama with contrasting ele-
ments: the sharpness between darks and lights,
weaving the objects and their reflections in and
out of the shadows, and the juxtaposition of
spherical grapes, striped fabric, triangular
watermelon wedges, and various sized patterns.

I am a painter at heart. I love color and surround myself with it in every aspect of my life. Like most
artists, there are times when I like a subtle palette and times when I like the drama of contrasting vibrant
colors. I started working with colored pencils over twenty years ago when I realized I couldn't work with
oil paint and live in the same space. Although working with colored pencils forces me to use color in a
very different way than oils—mixing and layering pigments on the paper instead of a palette—I find it
equally satisfying and more controllable.

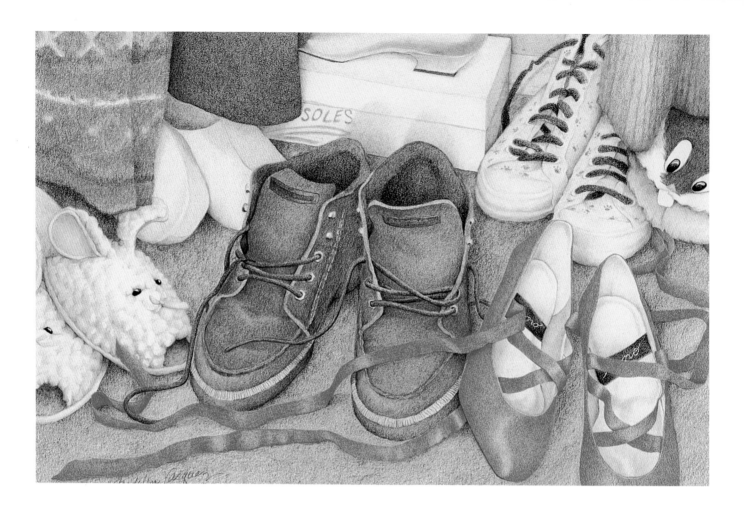

MADELINE VASQUEZ
Seduction
10 x 14 in. (24x34 cm)
Surface Used: Rising 2-Ply Museum Board,
 White

Vasquez's composition is organized clutter. She uses the hanging clothing to provide direction and act as a frame. The patterned robe repeats the dominating red for color balance and anchors the work. She impresses lines with a blunt sculpting tool and uses an electric eraser to create highlights and clean edges.

Most still life artwork is too "still" for me. I prefer some interaction to provoke curiosity—to imply that there is more than meets the eye. I decided to use my red satin shoes for a subject. They were so brazen and flirty, traits I always liked in a shoe. After several contrived attempts, I tossed the red shoes into the closet where they accidentally bumped into the work shoes. That was it! *Seduction*. I surrounded the star players with various onlookers. The piece took on a life of its own, and I wondered what would happen if I shut the closet door.

Circulism is my derivative of pointillism. Working with colored pencils, I draw no lines—only varied, overlapped, and intertwined circles that build transparent layers incorporating all color. As in pointillism, the viewer's eye fuses these colored circles into realistic shades of human flesh, hair, and life. This technique has allowed me to merge all that I crave about art—including my fascination with the human form; the flowing shapes that bend, stretch, fold, and change simply because of a persons mood; forms that may follow the same blueprint, but are never quite the same on any two people. I can never get bored with a subject that is so constantly fluid.

MAGGIE TOOLE, CPSA
A Warm Shoulder
18 x 24 in. (46x61 cm)
Surface Used: Clayboard, Taupe

Working with as many as seventy-five colors, Toole begins with medium-light values to plot the highlight areas over a grid. She keeps the shadow edges of the left arm and the knee blurred by making looser circles and overlapping them with the dark circles of the background. This conveys the foreshortening and advances the arm and knee from the darkness.

DIANE DONICHT VESTIN, CPSA
Still Life at Dusk
25 x 32 in. (64x81 cm)
Surface Used: Strathmore 500 100% Rag
 Illustration Board, Plate Finish, White

Vestin adds impact and emphasis to the simple blue and yellow objects with a red background. These primary colors are integrated through reflections and the transparency of the glass. The artist uses heavy pressure from start to finish, totally saturating the board with color.

My philosophy as an artist is that social, political, and moral statements about art in general deter the viewers' full potential of enjoying what the art can offer them. My compositions are based on beauty, form, and order. Whether the subject matter be from natural elements or man-made, the attempt to invoke the feelings, wonder, and awe of divine workmanship is an ever pressing goal. I am dedicated to technical excellence and the mastering of the medium used. My chosen subject matter and the way it is presented should be able to stand on its own and speak for itself.

My goals are fairly simple. I try to achieve something different with every piece: new color combination, different texture, or unusual display of light and shadow. In *The Times of Our Lives,* I dismissed a formal still life approach and constructed a composition that would resemble a collage. As the work progressed, I knew the times on each clock should represent something. Each clock face records a birth month and day of myself and my children. The gears offer some design complexity to contrast with the simplicity of the timepieces. The rose counterbalances the hard surfaces, geometric shapes, cool colors, and shallow depth of field.

JOY ROSE WALKER
The Times of Our Lives
28 x 24 in. (72x60 cm)
Surface Used: Arches 140 lb. Hot Press
 Watercolor Paper, White

To create a smooth base for the color layers that will follow, Walker begins with a layer of white. She uses small, even vertical strokes covering all of the paper. She lifts the tiny flecks of white seen in the background by tapping an electric eraser over the area.

GAIL WAGNER
Rousseau Series: The Hungry Lion
13 x 13 in. (33x33 cm)
Surface Used: Arches 140 lb. Hot Press
 Watercolor Paper, White

In the manner of Rousseau, Wagner avoids realistic renderings of form and light by emphasizing the two-dimensionality of shapes through outlines and exaggerating the contrasts between the shapes and the background. This creates a decorative appearance rather than a photographic documentation.

This painting draws a humorous analogy between the way Rousseau romanticized nature in his paintings and the way our culture romanticizes nature in lawn ornaments and other domestic trinkets. *Rousseau Series: The Hungry Lion* is based on Rousseau's painting heroically entitled: "The Hungry Lion Leaps upon the Antelope, Devours it, the Panther Anxiously Awaits the Moment When She Too Can Have Her Share. Birds of Prey Have Each Torn Out a Piece of Flesh from the Poor Creature Emitting a Cry! Sunset." To bring this into a contemporary framework, I replaced Rousseau's antelope with a common burro lawn ornament—drama is thus replaced with static syrupy cuteness.

Over the last twenty-seven years, I have raised about every farm animal imaginable and have found the rooster to be the most intimidating—a small bundle of energy with a bad attitude. Originally, the motivation for this piece was in capturing the color and texture of feathers. That motivation changed after one photo session. As I looked through my viewfinder, the rooster's head feathers immediately rose. Having been chased many times, I knew this was the only warning before roosters go into action. His mood was now my motivation, and I decided to portray him up close and personal. *Ruffled Feathers* is an example of my "fowl art."

RITA SUE POWELL
Ruffled Feathers
25 x 18 in. (64x47 cm)
Surface Used: Strathmore Acid-Free Artagain
 Recycled Flannel Paper, White with Blue Flakes

Powell uses only those colors that test six or higher on lightfastness reports compiled by the Colored Pencil Society, the American Society for Testing Materials, and colored pencil manufacturers. She uses an X-Acto knife to finish the highlights on the feathers.

DYANNE LOCATI, CPSA
Koi'n For A Swim
22 x 30 in. (56x76 cm)
Surface Used: Rives BFK Heavyweight
 Printmaking Paper, Buff

Using a wide variety of colors, Locati avoids cre-
ating muddy tones by placing complementary
hues, such as orange and blue, next to each
other rather than mixing them. She emphasizes
the water's movement and reflections with dark
and light visible lines.

The use of photographs for reference is wonder-
ful. But, I like to go a step farther and create my
own interpretations of the subject. I change colors,
move areas around the page, and abstract the
design. In this painting I used three photographs
to study the light and movement of the koi. I
stayed fairly true to the photograph for the fish's
eye and head. The rest of the fish was altered in
color, size, and shape. If you put your hand over
the fish's head, you will see a great deal of
softness, movement, and abstract qualities in
the tail section.

BARBARA NEWTON, CPSA
Heartfelt
25 x 18 in. (62x45 cm)
Surface Used: Strathmore 500 Bristol Plate

Newton builds a tonal foundation of French gray,
black grape, or indigo blue in all areas except
that of the main subject. By laying in her darkest
areas first, she has both ends of the value scale

In this painting, I used my husband's grandmother's crystal bowl
and my grandmother's cutwork linen tablecloth. Because these
two women kept these objects safe, they are now enjoyed by us,
and in time will be passed on to others. The red peppers, a
symbol of nurturing, are every bit as beautiful as the treasured
man-made objects. All three, set on the rough lumber of the
porch, made a dramatic statement of relationships: dark to light,
rough to smooth, common to elegant. The definition of "heart-
felt" is "deeply or sincerely felt." That describes my feelings in
bringing these ordinary objects together.

GLOSSARY

Analogous Color Scheme: Using the shades, tints, or tones of any three colors that are next to each other on the color wheel.

Background: The part of the composition that appears to be farthest from the viewer.

Bristol Board: A stiff, durable cardboard made in plate and vellum finishes with thicknesses of one- to four-plies.

Burnish: A technique of smoothing and blending layers of pigment that obliterates the paper's surface and leaves a glossy finish. May be done with a tortillon, burnishing tool, or a light-hued colored pencil.

Chiaroscuro (ke-AR-o-sk/y/oor-o): Creating the illusion of form and volume on a two-dimensional surface through the use and distribution of pronounced lights and darks. Classic precepts call for only one source of light.

Cold Press Paper: This refers to the medium-rough texture of the paper as a result of being pressed with cold weights during processing.

Collage: The process of constructing flat (or low-relief) two-dimensional art by gluing various materials (i.e., newspaper, photographs, etc.) onto the painting surface.

Colorless Blender: An alcohol-based, felt-tipped marker containing no color pigment. The clear solvent is used over one or more layers of dry pigment to produce a smooth, painted finish.

Complementary Colors: Any two colors that are opposite each other on the color wheel (i.e., red and green). These colors create a high contrast when placed side by side.

Contrast: The juxtaposition of extremes—as in colors (purple with orange), values (white with black), textures (coarse with smooth), etc.—within the composition.

Contour Drawing: Lines drawn to relate the edge of volume in an object.

Crosshatch: Colored pencil strokes applied at right angles to each other to create contrasting tone and density.

Drawing: A term applied to the dominance of lines as a means of defining shapes and forms.

Figurative: Any image that represents the human form as a figure, symbol, or likeness.

Fixative: A thin liquid of resinous solvent sprayed over colored pencil artwork to protect it from smudging and to eliminate wax bloom. It is available in workable, matte, and glossy finishes.

Focal Point: The center of interest or activity within a composition.

Foreground: The area of a painting that is nearest to the spectator.

Frisk™ Film: A brand of clear film backed with a low-tack, removable adhesive. It is commonly used to protect unfinished areas of a painting, but it is also used to remove, or lift, pigment from the surface.

Frottage: A technique of transferring the texture of a surface (such as wood, stone, etc.) by rubbing pigment on paper that has been placed over it.

Gradation: A fine progression of values. Also, the imperceptible blending of adjacent colors.

Graphite Paper: A thin paper coated with graphite used for transferring drawings done on tracing paper onto the art paper.

Grisaille (gree-sigh): A monochrome painting modeled in shades of gray. Commonly used as a base coat before applying colored pigments.

Hatching: Strokes of diagonal lines placed parallel to each other.

Hot Press Paper: This refers to the smooth surface of the paper as a result of pressing it between calendar rollers that flatten the grain into an even finish.

Hue: The actual color of anything. Also used to describe what direction a color leans toward (i.e. bluish green).

Illustration Board: Layers of paper adhered to a cardboard backing to produce a sturdy drawing surface. It is made in various thicknesses and textures.

Impressed Line: A technique of using a blunt instrument, such as a stylus, to etch lines into the surface of the paper. Color can then be added tonally while retaining the impression.

Key: Refers to the range of color values in a painting. High key work is dominated by light, bright, or pale colors. Low key work is dark and subdued.

Local Color: The true color of an object seen in ordinary daylight.

Museum Board: Available in two- and four-ply, this soft, textured surface absorbs wet or dry pigment readily.

Painting: A term applied to forms that are defined by the juxtaposition of color and values rather than lines.

Pencil Extender: An instrument that holds a pencil stub for longer use.

Pointillism: The technique of composing an entire image through the use of small dots of color.

Saturation: The intensity or brightness of a color.

Scumble: A light coating of a pigment rubbed or smeared over the painting to make it softer and less linear.

Sgraffito (skra-fee-toe): The method of creating designs by scraping the top layers of pigment to reveal the different colors of the underlying layers.

Stipple: To create an optical mix of colors through the use of dots or dashes.

Tonal Application: A coat of color finely applied with strokes or circles so that no linear marks are left visible.

Tooth: Refers to the depth of the grain of the paper.

Tortillon: Tightly rolled gray or white paper used for blending colors, also referred to as a "stump."

Value: The relative lightness or darkness of a color.

Vellum: A smooth cream-colored paper resembling calfskin.

Wax Bloom: Occurs when the concentration of wax in the layers of pigment rise to the top to create a "fog" that dulls and subdues colors. This usually happens when using heavy pressure on several layers, as in burnishing, and can be easily eliminated with light layers of fixative.

ARTISTS

Ackerman, Wendy Nelson 64
Albanese, Stephanie 65
Alello, Darryl d. 66
Auten, Bonnie 67
Avishai, Susan 68
Baisden, Jeffrey Ann Smart 70
Baker, Carol 72
Bascom, Joe 71
Beck, Alison 69
Berry, William A. 73
Blanchard, Nancy 11
Braun, Pauline A. 74
Bruce, Judith Orner 75
Byars, Eric 76
Byrem, Lynn A. 77
Campbell, Christopher 78
Chapman, Clare 79
Conwell, Kathryn 80
Cosentino, Cira 81
Couch, Anna P. 82
Curnow, Vera 5
Currier, Deborah 83
Cutri, Shannon 8
D'Amico, Luanne 84
Dahlgran, Dava 86
De La Penha, Billie 88
DeHaven, Martha 85
Deutsch, Ellen Roth 89
Dewar, Kay Moore 87
Doty, Sheri Lynn Boyer 90
Drayton, Richard 92
Dunlap, Doree 91
Edgardo, Vicente 6
Farfan, Rhonda 7
Farley, Claudia Jean 119
Fay, Nikki 93
Flynn, Caitlin 94
Francis, Bill D. 96
Freidel, Judy A. 95
Friesen, Chris 8
Gawron, Nancy 97
Gaylord, Donna 98
Geissbuhler, Stefan 99
Gelormino, Diane 100
Gildow, Janie 101
Gilger, Marsha 102
Gray, Cissy 103
Greves-Neilson, Sheri 104
Guthrie, Robert 105

Haas, Susan E. 106
Harvey, Tanya 107
Hershberger, Carlynne 108
Heussner, Priscilla 15
Hobbs, Mary G. 13
Huck, Richard W. 26
Hughes, Nancy 25
Hunter, Suzanne 27
Hyback, Susan Fulghum 28
Jackson, Blair 30
Jamieson, Judith L. 31
Johnson, Bruce 32
Kirk, Shari 85
Kline, Jill L. 29
Kritzberg, Susan 34
Kullberg, Ann 33
Lauzen, Diane 35
Lekan, Mary 36
Lewis, June S. 40
Lindenberger, Amy 37
Locati, Dyanne 140
Loomis, Sherry 39
Ludden, Rita 105
Mateer, James K. 44
McConnell, Carla 46
McDonald, Judy 45
McDonald, Ruth Schwarz 54
McKinney, Lou Ann 47
McLeod, Kathleen E. 49
McVey, Patricia Joy 50
Miles, Elisabeth 52
Mondloch, Linda 51
Moon, Rose 53
Mullarkey, Kimberly 49
Murray, D. J. 55
Neilson, Nicole 41
Nelson, Bruce J. 10
Nesbitt, Lorrie Matheson 56
Newton, Barbara 140
Nicol, Louisa 57
Nix, Mary Ellen 58
Nixon, Kathi Green 59
Noon, Susan K. 60
Ogan, Margaret J. 61
Pawelczyk, Stanley 62
Peanick, Cynthia Lock 42
Perkins, Ruth A. 43
Peterson, Cynthia 63
Pilcher, Gregory Steven 11

Powell, Rita Sue 139
Pratt, Sharon 109
Puls, Laurene 110
Rimerman, Jan 112
Robbins, Anna Marie 114
Roberts, Leslie 38
Russell, Mike 111
Sands, Elly 115
Sanocki, Connie 116
Sato-Wiuff, Mutsumi 113
Servoss, Allan 117
Sigmon, Cathy 118
Sims, Lee 39
Skoczen, Rita Mach 120
Smith, Anne Renard 121
Smith, Sharron E. 122
Snowman, Scott M. 124
Sorensen, Carol 123
Speth, Mardi 126
Stallings, Shirley 127
Stephens, Jean K. 125
Stephenson, Lynn M-W 128
Stripling, Iris 129
Sullivan, Don 130
Synoground, Kaye A. 131
Thayer, Jr., Thomas M. 48
Tomasik, Carol 132
Toole, Maggie 135
Tooley, Richard 9
Vasquez, Madeline 134
Vestin, Diane Donicht 136
Wadler, Ronni 133
Wagner, Gail 138
Walker, Joy Rose 137
Webster, Jennifer Phillips 14
Weinstock, Arlene 12
Wesner, Linda 17
West, Susan Y. 16
Westgard, Sylvia 19
Westlake, Laura 119
Whitener, Dena V. 18
Wikstrand, Jane 20
Woggon, Brenda J. 22
Wollam, Larry D. 21
Zinkus, Andrea L. 23
Zonker, Kenneth L. 24

DIRECTORY OF ARTISTS

Ackerman, Wendy Nelson
321 Lake Region Blvd.
Monroe, NY 10950
914-783-4690

Albanese, Stephanie
4 Locke Dr.
Pittsford, NY 14534
716-248-2655

°**Alello, Darryl d.**
218 Tate Rd.
Denham Springs, LA 70726
504-665-6936

Auten, Bonnie
213 E. Chicago Blvd.
Tecumseh, MI 49286
517-423-6184

Avishai, Susan
28 Marlboro St.
Newton, MA 02158
617-969-5451

°**Baisden, Jeffrey Ann Smart**
Route 7, Box 86
Live Oak, FL 32060
904-362-2635

Baker, Carol
32661 Pearl Dr.
Fort Bragg, CA 95437
707-964-2309

°**Bascom, Joe**
1550 York Ave.
New York, NY 10028
212-737-2191

Beck, Alison
13244 S. Leland Rd.
Oregon City, OR 97045
503-656-4303

Berry, William A.
908 Edgewood
Columbia, MO 65203
314-875-7823

Blanchard, Nancy
Permanent School Rd.
Erwinna, PA 18920
610-294-9040

Braun, Pauline A.
P.O. Box 381
75 Sturgeon Cr.
Thompson, MB R8N 1N2
204-778-6628

Bruce, Judith Orner
148 N. McKinley Pl.
Monrovia, CA 91016
818-357-1903

°**Byars, Eric**
RR#4
Flesherton, ON N0C 1E0
519-924-3578

Byrem, Lynn A.
324 North Nyes Rd.
Harrisburg, PA 17112
717-652-0187

Campbell, Christopher
945 Allspice Ave.
Fenton, MO 63026
314-343-1633

Chapman, Clare
140 Washington Rd.
Woodbury, CT 06798
203-266-4004

Conwell, Kathryn
809 NW 41
Lawton, OK 73505
405-353-7532

Cosentino, Cira
1357 NE Ocean Blvd.
Stuart, FL 34996
407-225-1389

Couch, Anna P.
538 Redlands Ave.
Newport Beach, CA 92663
714-631-3946

°**Curnow, Vera**
The Electric Pencil Company
1620 Melrose Ave. #301
Seattle, WA 98122
206-622-8661

Currier, Deborah
P.O. Box 772126
Steamboat Springs, CO 80477
970-879-7907

Cutri, Shannon
461B Idyllbrook Village Dr.
Erie, PA 16506
814-838-7463

De La Penha, Billie
116 Col. Culcock Ct.
Bhuffton, SC 29910
803-695-5013

DeHaven, Martha
106 La Vista Dr.
Los Alamos, NM 87544
505-672-3342

Deutsch, Ellen Roth
1150 Knollwood Dr.
Buffalo Grove, IL 60089
847-634-3278

Dewar, Kay Moore
3056 39th Ave. SW
Seattle, WA 98116
206-935-2634

Doty, Sheri Lynn Boyer
4540 South 2295 East
Salt Lake City, UT 84117
801-582-2716

Drayton, Richard
85 Highland Dr. S
Sedona, AZ 86351
520-284-9125

Dunlap, Doree
177 Riverside Dr., Suite F
Newport Beach, CA 92663
714-720-1740

Edgardo, Vicente
721 West 50th St.
Chicago, IL 60609
312-285-7170

Farfan, Rhonda
25318 Ferguson Rd.
Junction City, OR 97448
541-998-3608

Fay, Nikki
P.O. Box 422
Philomath, OR 97370
541-929-6318

°**Flynn, Katharine**
P.O. Box 2396
Sedona, AZ 86336

Francis, Bill D.
1100 Yaupon Valley Rd.
Austin, TX 78746
512-327-0394

Freidel, Judy A.
2382 Highway 7 N
Hot Springs, AR 71909

Friesen, Chris
1945 Eola Dr. NW
Salem, OR 97304
503-581-6187

Gawron, Nancy
32 Delaware Ave.
Red Bank, NJ 07701
908-741-7523

°**Gaylord, Donna**
1980 W. Ashbrook Dr.
Tucson, AZ 85704
520-297-6257

Geissbuhler, Stefan
10854 W. Evans Ave. #48
Lakewood, CO 80227
303-986-5094

Gelormino, Diane
21100 NE 246th Cr.
Battle Ground, WA 98604
360-687-6173

°**Gildow, Janie**
905 Copperfield Lane
Tipp City, OH 45371
513-335-3570

Gilger, Marsha
11827 Fraze Rd.
Doylestown, OH 44230-9713
216-658-5035

Gray, Cissy
7531 85th Pl. SE
Mercer Island, WA 98040
206-236-2510

Greves-Neilson, Sheri
24347 Fairway Dr.
Davis, CA 95616
916-756-2727

°**Guthrie, Robert**
3 Copra Lane
Pacific Palisades, CA 90272
310-454-7533

Haas, Susan E.
Mount Morris Star RT
Waynesburg, PA 15370
412-627-8066

Harvey, Tanya
40237 Reuben Leigh Rd.
Lowell, OR 97452
541-937-1401

Hershberger, Carlynne
1016 NE 3rd St.
Ocala, FL 34470
904-622-4943

°**Heussner, Priscilla**
916 Whitewater Ave.
Ft. Atkinson, WI 53538
414-563-5346

Hobbs, Mary G.
65 Carriage Stone Dr.
Chagrin Falls, OH 44022
216-247-4275

Huck, Richard W.
615 W. Marion St.
Lancaster, PA 17603
717-392-1214

Hughes, Nancy
608-B S. 4th St.
Smithfield, NC 27577
919-989-7748

Hunter, Suzanne
6752 Fiesta
El Paso, TX 79912
915-584-1074

Hyback, Susan Fulghum
4875 Owen Rd.
Memphis, TN 38122

Jackson, Blair
6318 Waterway Dr.
Falls Church, VA 22044
703-642-0937

Jamieson, Judith L.
7223 SE Tolman
Portland, OR 97206
503-771-7510

Johnson, Bruce
1205 S. Hawthorne
Sioux Falls, SD 57105
605-330-9542

Kirk, Shari
1084 Ascot Dr.
Richardson, TX 75081

°**Kline, Jill L.**
342 Whetstone #6
Marquette, MI 49855
906-228-2769

Kritzberg, Susan
P.O. Box 47
Yorkville, IL 60560
708-553-5835

°**Kullberg, Ann**
31313 31 Ave. SW
Federal Way, WA 98023
206-838-4890

Lauzen, Diane
Route 3, Box 632
Aurora, IL 60506
708-892-6276

Lekan, Mary
Montrose, CA 91020

Lewis, June S.
906 Kumukoa St.
Hilo, HI 96720

Lindenberger, Amy
825 E. Maple St.
N. Canton, OH 44720
216-494-8951

°**Locati, Dyanne**
6720 Doncaster
Gladstone, OR 97027
503-659-6904

Loomis, Sherry
P.O. Box 175
Arroyo Grande, CA 93421
805-489-6490

Ludden, Rita
Studio 329
105 N. Union St.
Alexandria, VA 22314

Mateer, James K.
218 Wenner St.
Wellington, OH 44090
216-647-5123

McConnell, Carla
729 W. Broadway
Montesano, WA 98563
360-249-4810